5/00

ALBUQUERQUE ACADEMY
SCIENTIA AD FACIENDUM
1955

This book was donated
in honor of

John Ashe

by

Dr. & Mrs. David Hillson

24 May 2000

DATE

Secret Worlds

PHOTOGRAPHS BY STEPHEN DALTON

Secret Worlds

PHOTOGRAPHS BY STEPHEN DALTON

FIREFLY BOOKS

A FIREFLY BOOK

Published by Firefly Books Ltd. 1999

First Printing 1999

Library of Congress Cataloging-in-Publication Data

Dalton, Stephen.
 Secret worlds : thirty years of nature photography / Stephen Dalton – 1st ed.
[160] p. ; col. ill. ; cm.
Includes index.
Summary : More than 125 images captured over three decades of high-speed nature photography.
ISBN 1-55209-384-0
1. Nature photography. 2. Outdoor photography. I. Title.
778.93–dc21 1999 CIP

Published in the United States in 1999 by
Firefly Books (U.S.) Inc.
P.O. Box 1338, Ellicott Station
Buffalo, New York 14205

Produced by
Bookmakers Press Inc.
12 Pine Street
Kingston, Ontario K7K 1W1
(613) 549-4347
tcread@sympatico.ca

Design by
Janice McLean

Printed and bound in Canada by
Friesens
Altona, Manitoba

Printed on acid-free paper

Canada

The Publisher acknowledges the financial support of the Government of Canada through the Book Publishing Industry Development Program for its publishing activities.

Dedicated to "The Dragon"

Canadian Cataloguing in Publication Data

Dalton, Stephen
 Secret worlds : thirty years of nature photography

Includes index.
ISBN 1-55209-384-0

1. Nature photography. 2. Photography, high-speed. I. Title.

TR721.D34 1999 778.94'3 C99-930381-3

Published in Canada in 1999 by
Firefly Books Ltd.
3680 Victoria Park Avenue
Willowdale, Ontario M2H 3K1

ARCHIVAL DISPLAY PRINTS

All the photographs in this book are available as high-quality archival display prints. For more information, please contact Stephen Dalton at sdalton@nhpa.co.uk

CONTENTS

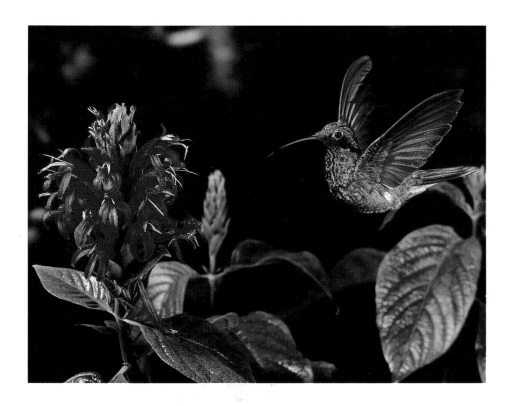

SPARKLING VIOLET-EAR
(*Colibri coruscans*)

Early Days

Anyone armed with a modern 35mm camera, a long lens and a smattering of ability can produce technically acceptable wildlife photographs. Nine times out of ten, the camera will focus and expose the picture perfectly at the press of a button—if you can find your subject and get close enough to it, that is. Nowadays, the main trick to successful wildlife photography, at least in the field, is to be at the right spot at the right time—that and choosing the right moment to press the button.

Life for a budding wildlife photographer was very different when I began to take nature photographs as a student during the early 1960s. The style of work was governed by the technical restrictions at the time. Most cameras used by the relatively few nature photographers were large and cumbersome view cameras that often required glass plates. The limited range of 35mm models lacked refinements such as TTL metering; indeed, on-camera metering of any sort was a rare luxury, while autofocus and motor drives were unheard of. Some mod-

els did not even have instant return mirrors or automatic diaphragms. A compounding problem was the matter of speed—films, particularly good-quality color emulsions, were very slow, as were lenses.

It was hardly surprising, therefore, that photographs of wildlife tended to be static, although often stunning, portraits of birds standing or sitting by their nests, of giraffes gazing into the distance and, more ambitiously perhaps for those days, of an insect—sometimes anesthetized!—sitting on a leaf. Those brave enough to tackle action photography almost invariably produced disappointingly fuzzy results. This was the world into which I chose to launch myself as a professional nature photographer.

At that stage, my main passion was insect photography, and I devoted much of my time as a student on techniques for obtaining sharp pictures of insects going about their lives in the field, using portable flash—a new high-tech tool at the time. It was all exciting, pioneering stuff. Fortunately, my work in this area did not go unnoticed, and a

well-known New York publisher offered me my first assignment, one that I accepted with alacrity. It was to illustrate a book on the life of honeybees—all in black and white.

As the project approached its conclusion, it dawned on me that I had recorded almost every aspect of the bees' lives except the most important: flight. Yet the insects' ability to fly is the reason honeybees, together with birds, are among the most successful group of animals on the planet. Further investigation disclosed that no photographs of even moderate quality showing insects in flight existed. There was no means of observing in a still picture how an insect used its wings to make the incredible maneuvers we take for granted. No technique was capable of stopping an insect in free flight with absolute clarity. Seeking the solution to this problem was to become my overriding obsession for the next few years—an obsession that, as it turned out, would shape my future.

My objectives were twofold. First, I wanted to record flight behavior

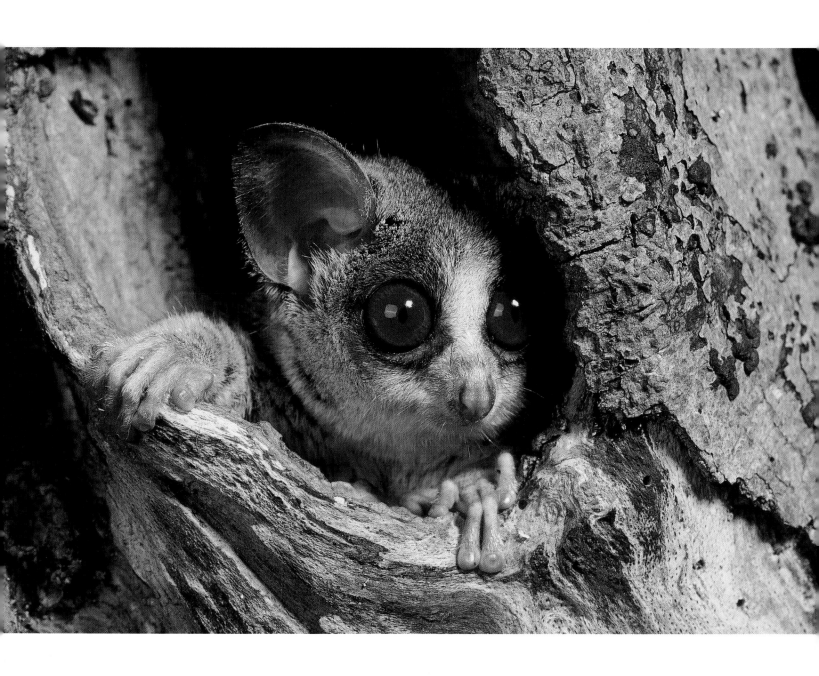

LESSER BUSH BABY (*Galago senegalensis*)

and wing movements—to show every twist of the wing, every scale and hair in critical focus. Second, and just as important, the insect had to be flying in a setting that evoked the beauty of its natural habitat. So followed one of the most exciting periods of my career. Over the next two years, I developed techniques and equipment that would allow me to capture on film the miracle of insect flight.

I devoted the next few years almost entirely to photographing flying insects. As it was—and still is—impractical and virtually impossible to conduct the operation in the field, the work all had to be done inside. In their natural habitat, insects, unlike birds, rarely fly where you want them. It may take hours or days to set up and adjust the optical and electronic paraphernalia needed to get everything just right, after which the particular insect might not appear at all. In addition, the merest suggestion of a breeze or rain can render the whole exercise a complete waste of time.

Yet studio nature photography is, in many ways, much more demanding than working in the open, whether one is dealing with snails or flying insects. In the open air, nature does most of the hard work, taking care of aspects such as background and lighting; the skill of the photographer lies in selecting the most appropriate viewpoint and moment. A studio situation, however, is completely different. One begins with a bare table on which a "biologically truthful" setting has to be built up, but it must be carefully planned to encourage the animal to fly, jump or meander to the right spot with minimal stress to itself. The shape, color and arrangement of picture elements, together with a natural and sensitive handling of lighting, all play a vital role in evoking the ambience of the animal in its native surroundings.

Once I had flying "bugs" under my wing, I turned my attention to other animals. After all, if the techniques worked with insects, they should certainly work with larger animals whose actions were likewise too fast to be stopped by conventional photography. In the following years, after photographing frogs, toads, snakes, lizards, rodents, fleas (insects again) and, of course, birds, I discovered that I much preferred high-speed work to conventional nature photography. Not only did the results reveal aspects of movement and behavior that had largely eluded us, but I enjoyed both the technical challenge and the stimulation of creating a picture from scratch. Thus I make no excuse for including a liberal measure of high-speed photography in this collection.

Although there are plenty of unpublished photographs here, a number have been selected from previously published books, but all have been arranged in approximate chronological order from the 1970s to the 1990s. A short summary of each of the three decades is given at the beginning of the relevant sections.

It should not take readers long to discover that apart from the limited series of pictures taken in the tropical forests of Venezuela, alien creatures in alien habitats do not feature prominently in *Secret Worlds*. Because I have never relished the prospect of physical discomforts or had the stamina to heave heavy equipment around harsh habitats, I have tended to avoid such trips. Moreover, contemplating a little mouse scuttling about in the leaves or a spider building its web gives me as much pleasure as watching elephants at a water hole—well, almost! This largely explains why much of my work has centered close to home—more often than not, within a few hundred yards of my front door.

Finally, I am frequently asked about my feelings toward our declining natural world and how it influences my work. The answer to the first part of the question is relatively simple. The overwhelming threat facing the world in the medium and long term is the destruction of its life-forms and habitats. Whenever we destroy nature, we create "hell" for other species and, in the long run, for ourselves. We should treat natural things and habitats in the same way that believers in established faiths treat their shrines and temples: as sacred, to be revered and preserved in all their fragile and intricate beauty. If all mankind felt this way, there would indeed be hope of saving what matters above all else—natural beauty and life as we know it. In answer to the second part of the question, I like to think that the work of nature photographers in some way contributes to the fostering of such feelings.

Stephen Dalton

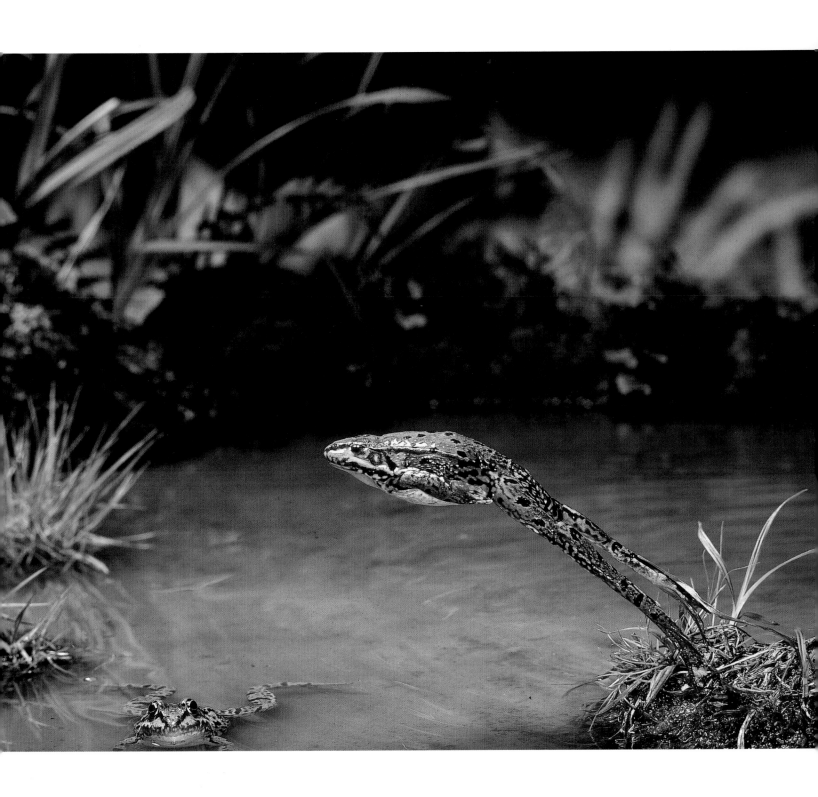

MARSH FROG (*Rana redibunda*)

Breaking the High-Speed Barrier

During the early 1970s, much of my time was devoted to developing and perfecting equipment and techniques for high-speed nature photography. My earlier work with honeybees had forewarned me of some of the difficulties that lay ahead, but I was so fascinated with the subject, I was determined to make a serious effort. It was a tremendously exciting time, and as with so many things, the trick was to isolate each of the challenges and tackle them one by one.

A smattering of knowledge of electronics and an interest in home-made gadgets helped me to achieve my goals. In simple terms, the central problem was that insects are unpredictable in their flight behavior—they are very fast and, compared with other flying animals,

very small. Human reflex action is not nearly fast enough to fire the camera at the exact moment that the insect flies into focus.

Additionally, because insects beat their wings at up to 1,000 cycles per second, high flash speeds are required to stop the action on film. Thus it was necessary to develop a flash unit sufficiently fast yet powerful enough to arrest all wing movement (about 1/25,000 second) as well as a sensor and triggering system, using light beams, photo-cells and amplifiers, that would be sensitive enough to detect small, active creatures. And since the insects had to fly in normal bright light, a special shutter had to be designed to open within roughly 1/500 second of the beam's being broken by the flying insect—all

conventional shutters being some 20 times too slow. Nowadays, of course, many of the technical obstacles can be dispensed with comparatively easily, but at that time, the prospect of achieving success was daunting. Within two years, however, I had a series of fascinating pictures, most in black and white, of insects in free flight.

I remember looking at the negatives, still dripping fresh from the developing tank, and being swept away by the sight of things no one had ever set eyes on before: insects in free flight, with every twist of the wing and every scale and hair in critical focus. It was an exhilarating and moving experience, so much so that apart from close family members, I did not show any of my photographs to another living soul for more than a year.

STAG BEETLE (*Lucanus cervus*)

One of Europe's most impressive insects, the stag beetle is a difficult subject for a neophyte nature photographer to resist. The beetle is found around old rotting oak trees on which the grub feeds, but as old trees tend to be removed in the interest of "neatness," this insect is far less common now than it used to be.

During courtship, the males often quarrel, but they rarely, if ever, injure one another. While their huge mandibles may look formidable, they are, in fact, weak and harmless. The female's smaller jaws, on the other hand, are capable of inflicting a painful nip.

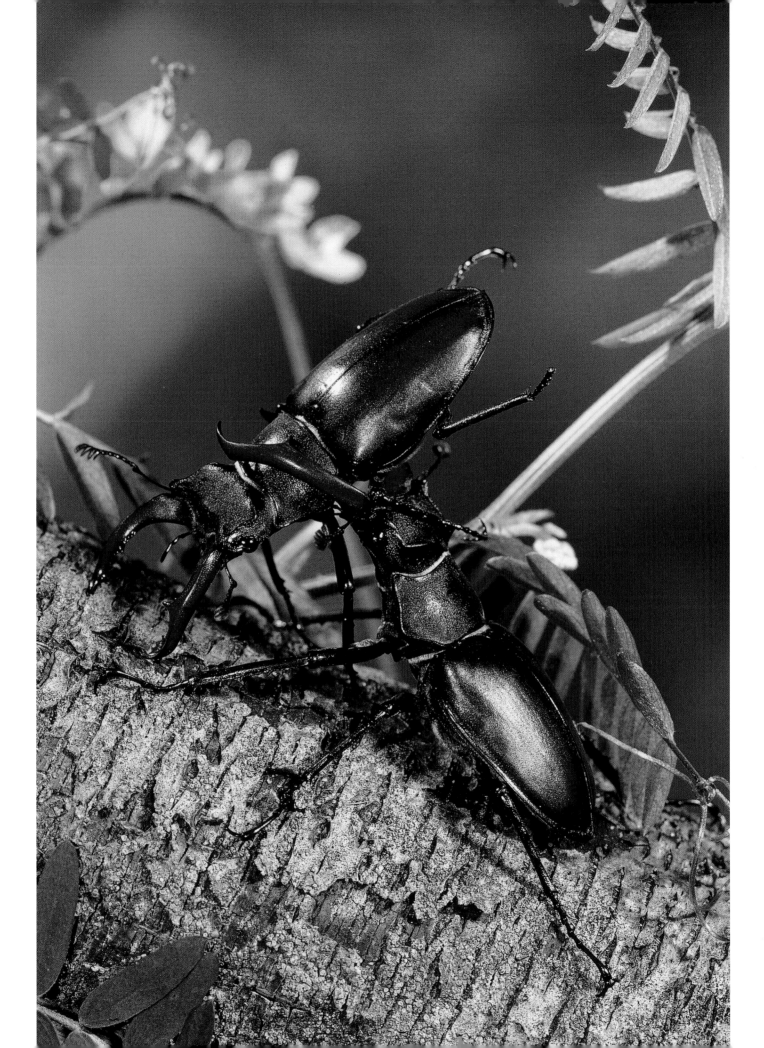

After a few introductory early photographs, the first part of *Secret Worlds*, then, concentrates on high-speed work and begins with my initial attempts at insect-flight photography, including some work undertaken during a visit to Florida's Everglades. After a few years devoted to insects, it seemed logical to try my skills on larger animals, such as birds, amphibians and reptiles (examples of these follow the insects). When an international magazine commissioned me to illustrate an article about the feeding techniques adopted by bats, I eventually tackled these fascinating mammals as well. That assignment subsequently took me to Germany, New York, Venezuela and New Mexico.

The next time I had an opportunity to come to grips with exciting and unfamiliar creatures was in the late 1970s, when the BBC made a film about my work. I was asked where I would most like to go in the world to use my high-speed camera. My unhesitating reply was: South America, the continent with more life than any other. I chose an exotic location, albeit a relatively cool one, in the cloud forests of Venezuela. This chapter ends with a selection of the pictures taken during that short visit.

WATER VOLE (*Arvicola terrestris*)

Some 30 years ago, I was fortunate enough to stumble upon a thriving colony of water voles, or water rats, around the margins of a remote willow-encircled pond. This beguiling little mammal, immortalized as Ratty in Kenneth Grahame's *The Wind in the Willows*, is not a rat at all but a true vole. More often heard than seen, it plunges into the water at the approach of danger, reappearing several yards away.

The only way I was able to attract the animal to the part of the bank where the camera was focused was to use fresh willow leaves as bait. All other inducements were consistently ignored.

Unfortunately, the water vole is now on the endangered list as a result of the habitat destruction and pollution that is rapidly spreading across the globe.

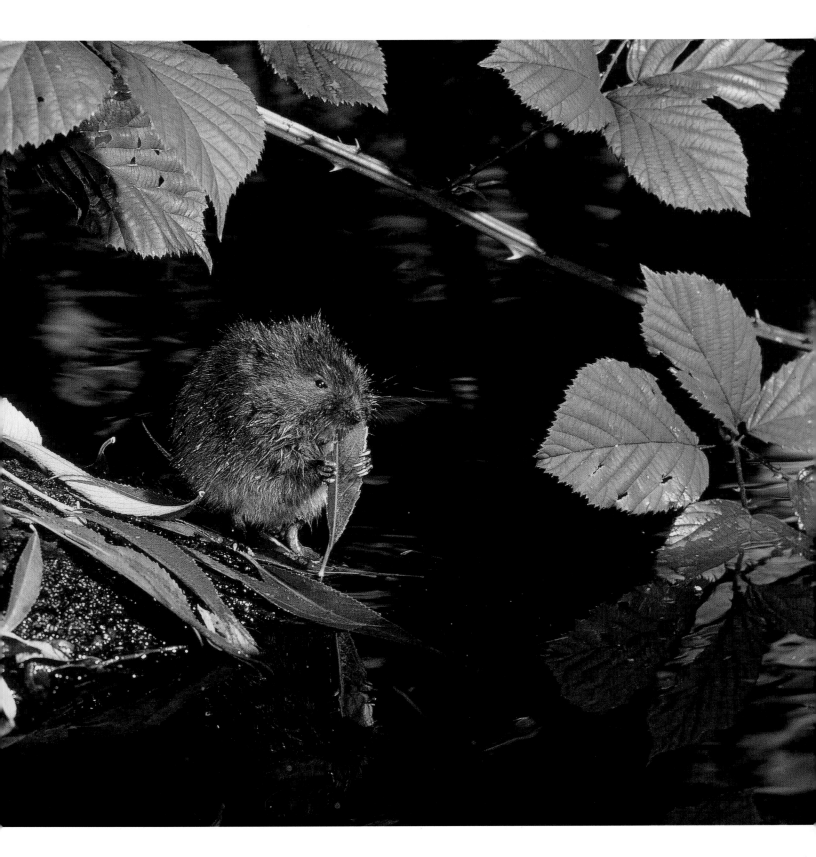

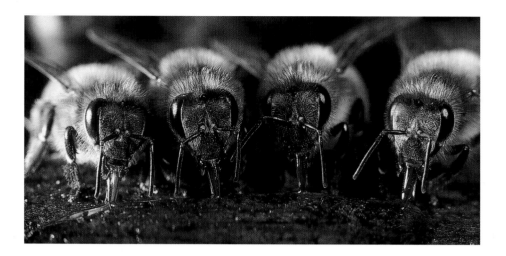

HONEYBEE (*Apis mellifera*)

Worker honeybees forage not only for pollen and nectar but also for water, as large quantities are required to dilute the food for the growing larvae in the brood comb. For this reason, a great many workers are recruited as water carriers. They are guided to the source of water—in this case, a bird-bath—by their water-vapor-sensitive antennae.

HARVEST MOUSE (*Micromys minutus*)

Unlike the majority of rodents, the harvest mouse is diurnal, living in thick vegetation where it uses its prehensile tail as a fifth leg to clamber about. This delightful little mammal is scarce now, another victim of habitat loss.

I soon discovered that a conventional flash was not fast enough to stop the perpetually quivering and twitching body movements of a small rodent. The first roll of exposed film did not contain a single sharp picture, so the photography had to be repeated using a prototype high-speed unit.

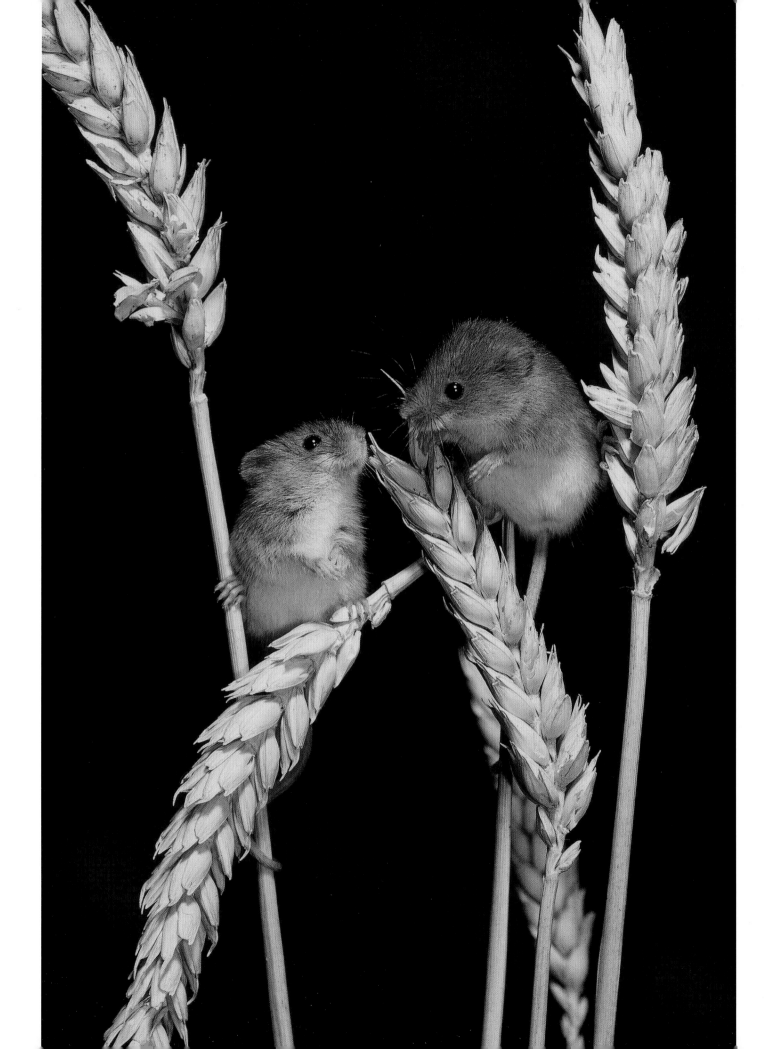

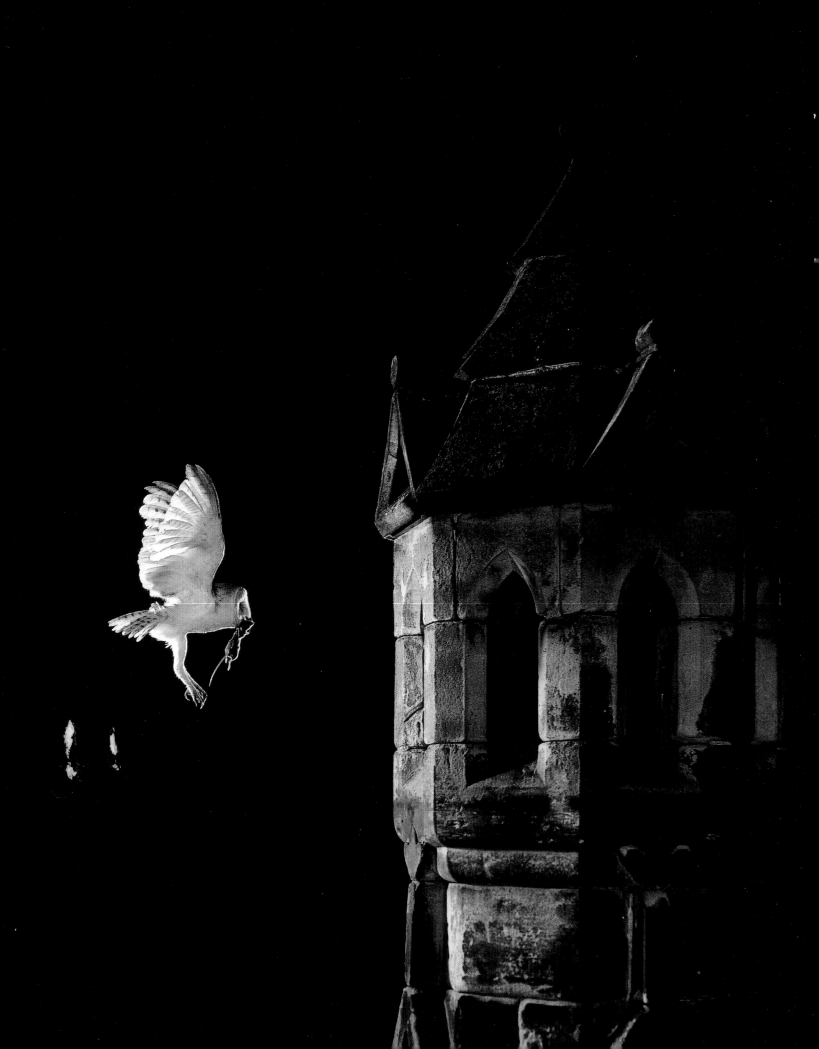

BARN OWL (*Tyto alba*)

On two occasions, I have been able to photograph barn owls flying in and out of towers. The first was in 1970, when I was beginning to experiment with high-speed flash. At that time, I was developing techniques and equipment with which to photograph insects in free flight. When a pair of owls elected to nest on the roof of a nearby church, I had a perfect opportunity to test both the equipment and my skills.

The operation took about three weeks to complete and necessitated my building a hide high up on the rooftop. Seven of the eight entrances to the octagonal tower had to be blocked off with black velvet, and there was such a serious risk of being attacked by the wild bees which had taken up residence in the roof that I had to wear a bee veil when preparing the site during the day.

The main problem, however, was my extremely temperamental flash and optoelectronic triggering system, which broke down almost every night. At that time, I had no way of reliably opening the shutter electronically, so I had to use an "open flash"—the shutter was manually opened a split second before the owl broke the beam that fired the flash. Despite these setbacks, I eventually got a picture of the parent bird flying into the entrance with a young rat in its beak.

Although there have been attempts to reintroduce the barn owl to areas it has been forced to vacate, the population of this hauntingly beautiful bird is steadily dwindling.

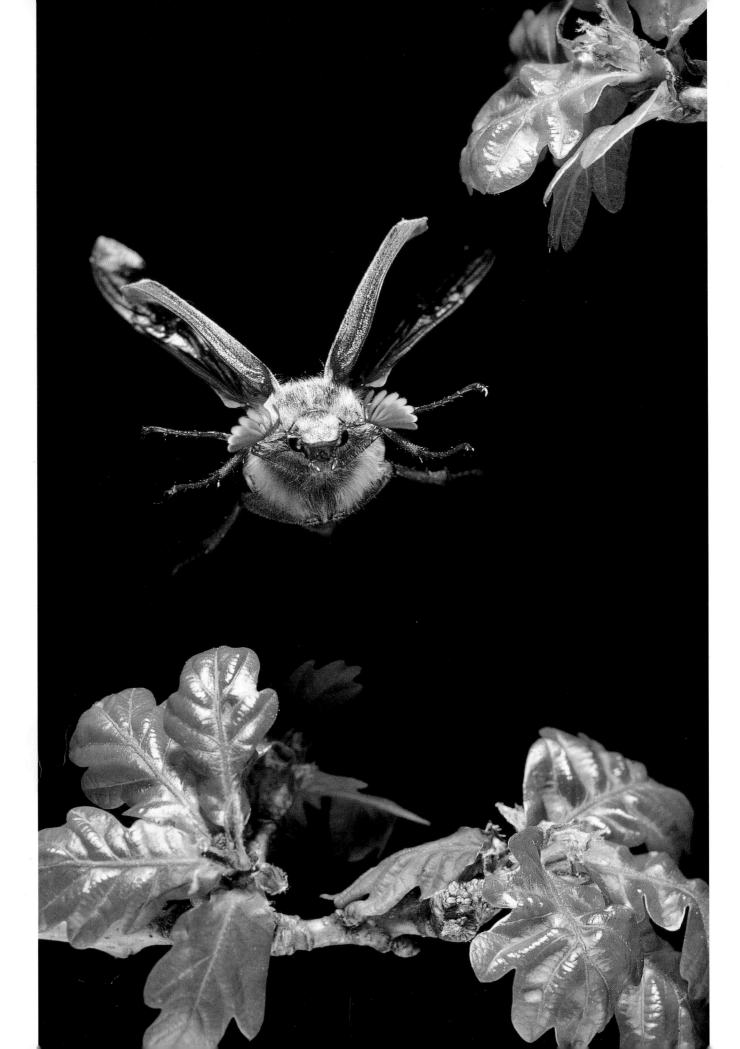

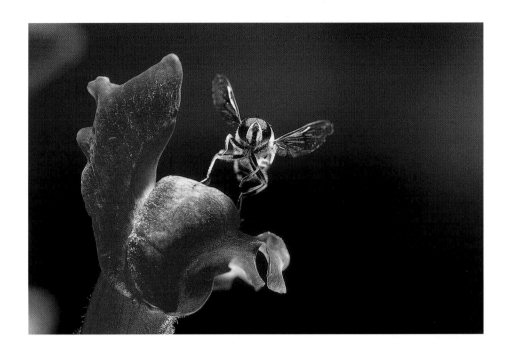

HOVER FLY (*Eristalis tenax*)

As hover flies are among the most predictable of insects on the wing, I frequently recruited them in my early days of flight photography for testing techniques and equipment.

This picture highlights an interesting aerodynamic feature of insect flight. Unlike aircraft, which do not generate any lift until their wings have moved some distance from a stationary position, insects can derive lift as soon as their wings start moving. Here, the hover fly is almost airborne before its wings have completed a quarter of a cycle.

COCKCHAFER (*Melolontha melolontha*)

This picture of a cockchafer, or May bug—one of the first photographs ever taken of an insect in free flight—received much publicity in the early 1970s, winning press awards and being featured on the covers of numerous magazines and newspapers.

The cockchafer is a member of the Scarabaeidae family, which includes some of the world's largest and most impressive beetles. Other relatives are the giant African goliath beetle and the five-inch-long hercules beetle of South America. The cockchafer cannot fly until it has filled several air sacs in its body. Even then, it has difficulty becoming airborne and is a slow, clumsy and noisy flyer.

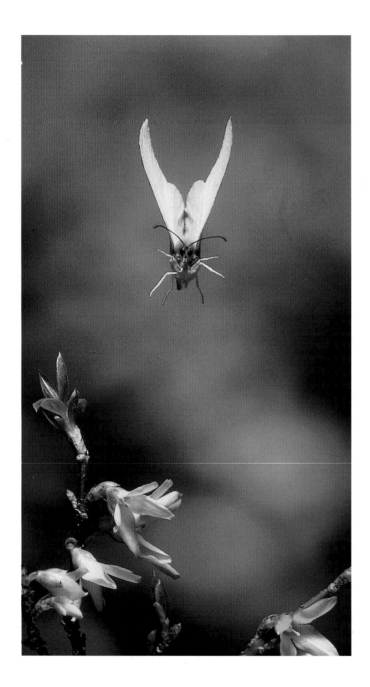

BRIMSTONE BUTTERFLY (*Gonepteryx rhamni*)

The name "butterfly" actually originated with this lovely sulfur-yellow insect, called the "butter-colored-fly" in medieval days. One of the first insects to emerge in spring, the brimstone can sometimes be seen flying on warm February days before the last remnants of snow have disappeared from the northern slopes.

In flight, the pale greenish white female can easily be mistaken for the cabbage white, a close relative, but *G. rhamni* has a stronger and more direct manner of flying. The photograph shows a male flying over forsythia flowers taken from the garden in early spring.

SPURGE HAWK MOTH (*Celerio euphorbiae*)

It is difficult not to get excited by hawk moths. With their thick and beautifully streamlined bodies, packed with powerful flight muscles, and their long, narrow, pointed front wings, hawk moths are the night falcons of the insect world. They are sometimes called hornworms, as the caterpillar of most species possesses a prominent horn on its back—a rather insulting name for such a splendid creature.

One of southern Europe's loveliest moths, the spurge hawk, pictured here, displays various subtle shades of green, brown, pink and black on its upper wing surfaces.

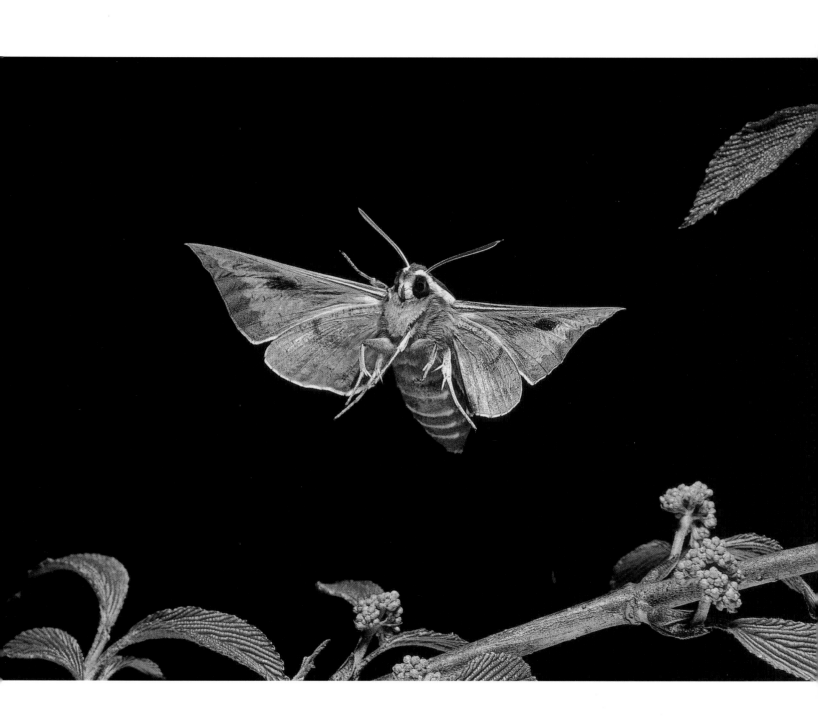

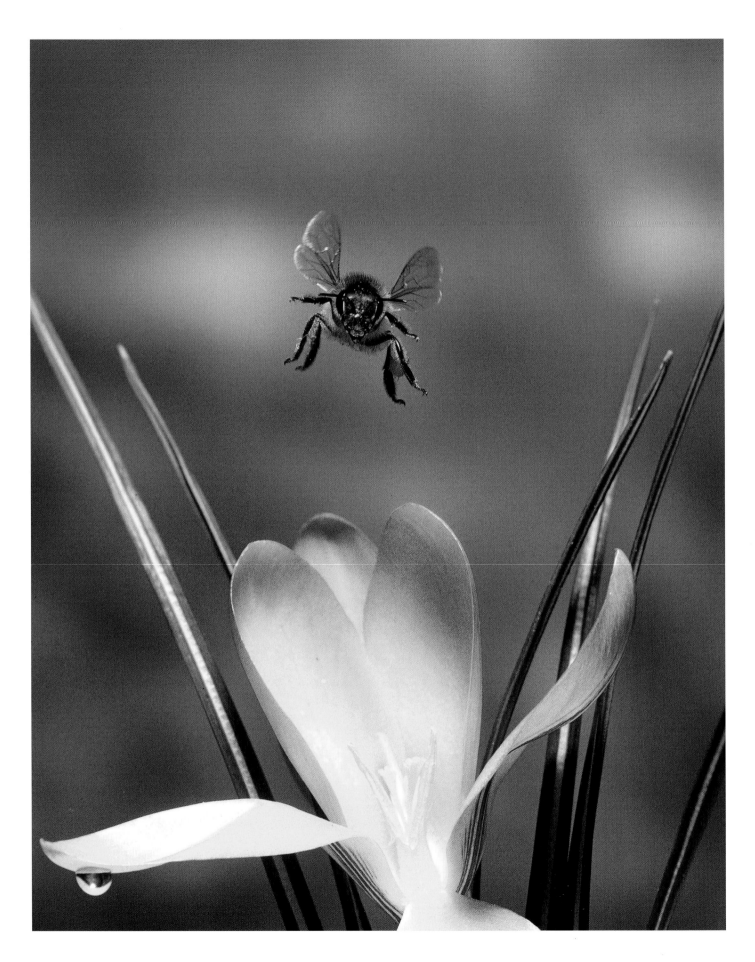

HONEYBEE (*Apis mellifera*)

During the 1960s, one of my first photo assignments was to illustrate a book on the honeybee. Only then did I realize that the most important aspect of the honeybee's life—its ability to fly—had never been successfully recorded on film.

I became determined to photograph insects in free flight, a decision with far-reaching consequences. I can't count the number of times I have recorded flying honeybees since, but this photograph is one of my early successful attempts.

With a wing-beat frequency of about 250 cycles per second, the honeybee provides a demanding test for high-speed flash. In addition to the manufacturer's quoted figures (which cannot be relied upon), the stopping power of a flash depends on several factors. The wingtip is moving at maximum speed when halfway through its cycle but is stationary for a brief moment at the top and bottom of each stroke. Furthermore, the tips of the wings move at twice the speed of the wings halfway along their span. The magnification of the image also affects image sharpness: the larger the image size, the greater the image movement on the film.

If you are of a scientific disposition, these variables can be calculated by taking account of flash output curves, angular velocities, ratios of reproduction and circles of confusion, all before you even remove the camera from its bag. In practical terms, however, it simply means that whereas 1/5,000 second may be sufficient to arrest a bee's wing movement at the top of a stroke at a magnification of one-fifth, 1/50,000 second may scarcely be fast enough to freeze the wing when midway through the stroke at a reproduction ratio of 1:1—an interesting point, perhaps, for budding high-speed nature photographers.

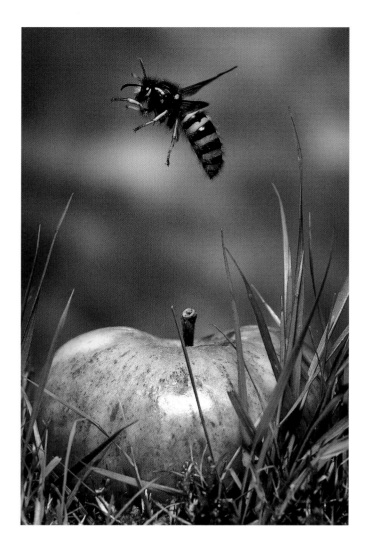

WASP (*Vespula vulgaris*)

Wasps create their colonies in large, round, papery nests that they build underground, in hollow trees or in attics. Unlike bees, wasps are omnivorous, feeding on insects, spiders and bits of meat as well as vegetable matter. Their tongues are much shorter than those of bees, however, so wasps are unable to suck nectar from deep flowers. Juices from fruits are a convenient source of food, especially during late summer, when wasp colonies are flourishing.

The common wasp, or yellow jacket, occurs not only in North America but also in Europe, where it is the most widespread species of social wasp. It has become established in New Zealand as well, where so many other animal species have also been naively introduced.

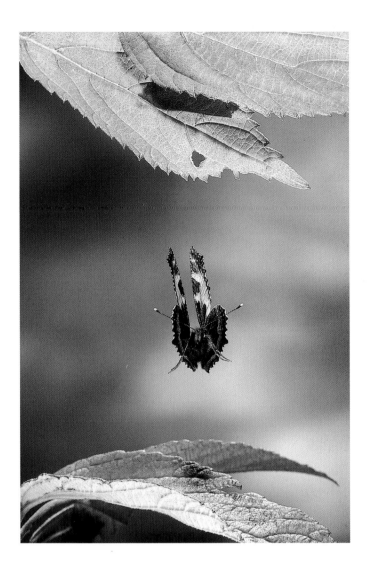

SMALL TORTOISESHELL (*Aglais urticae*)

The small tortoiseshell is a member of the largest and most widely distributed family of butterflies in the world—the nymphalid, or brush-footed, butterflies. One of the most common species in northern Europe, the small tortoiseshell can also be found throughout Asia and as far east as Japan. It seems equally at home in city gardens, in woodlands, in alpine meadows and on the banks of mountain streams. Like the brimstone butterfly, it hibernates, seeking out protected niches in barns, attics, cellars and hollow trees.

RHODODENDRON LEAFHOPPER
(*Graphocephala coccinea*)

A common bug throughout North America, the rhododendron leafhopper was not introduced to England until 1935. The insect is reputed to be a carrier of bud blast, a fungus disease, but my rhododendron used to be alive with the creatures, and the shrub was one of the healthiest specimens around.

The leafhopper is an extremely active leaping bug and, like the grasshopper, has powerful hind legs. It earned its common name "dodger" because when alarmed, it often dodges around to the other side of the leaf or twig only to peep out a few moments later to check whether all is clear. If the situation still looks uncertain, it retreats once more, and if things are really threatening, it then half leaps and half flies to a safer perch.

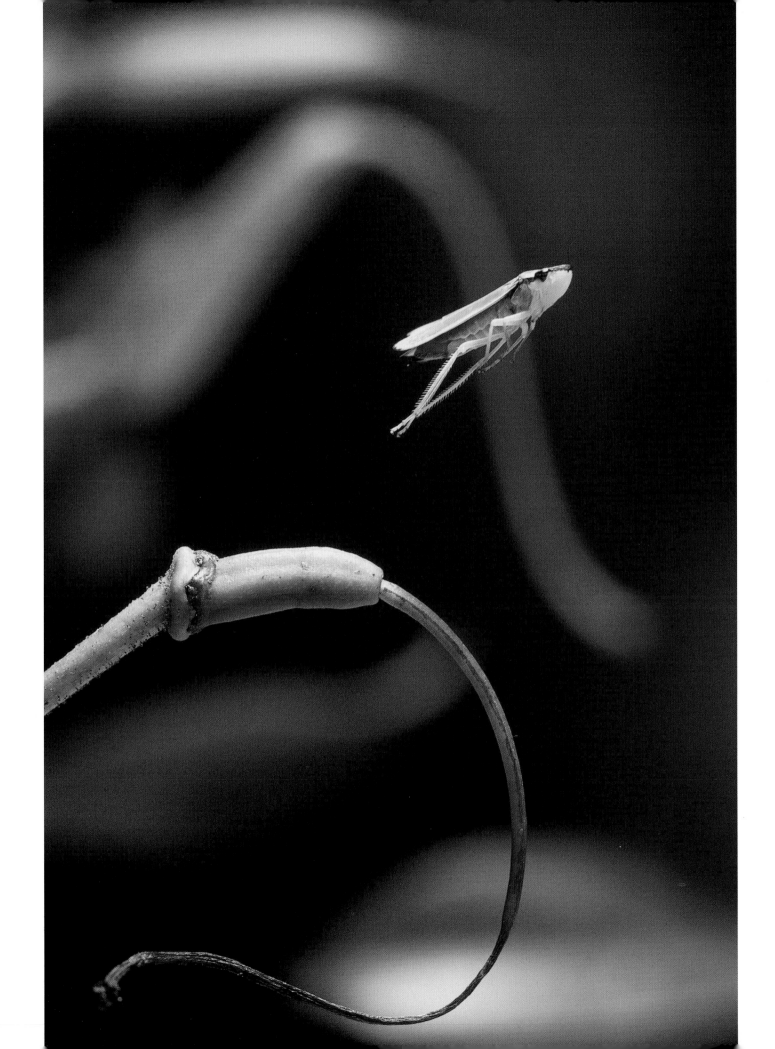

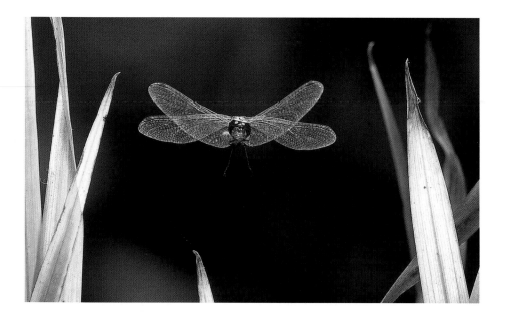

COMMON DARTER (*Sympetrum striolatum*)

In my experience, a successful nature photograph is rarely due to luck. Unlike 99 percent of insect-flight work, which may eat into many days and as many films per subject, the photograph of this common darter took only part of a day to set up and just two exposures before the insect flew out of a half-open window. One of those pictures is reproduced here.

A familiar European species, the common darter is especially visible in late summer and autumn, when its numbers are reinforced by large swarms migrating from Continental Europe. Fond of basking on roads and garden paths, the darter can sometimes be found a long way from water. This dragonfly is typically restless, returning again and again to luxuriate in the same spot after short, rapid flights.

GREEN LESTES DAMSELFLY (*Lestes sponsa*)

Looking like a visitor from outer space, this finely structured helicopterlike damselfly darts between moss-covered stones. Unlike some dragonflies, the green lestes damselfly rarely strays far from the fringes of vegetation that border ponds and still waters.

Because I wanted a head-on picture to show the independent wing movement of the insect as it flew directly in the center of the stones, with its wings absolutely sharp in the "X" position at the limit of their span, I had to expose many films before I was satisfied. I found my subjects living around a small pond about six miles away, and they had to be freshly caught, photographed and released back to the same spot each day.

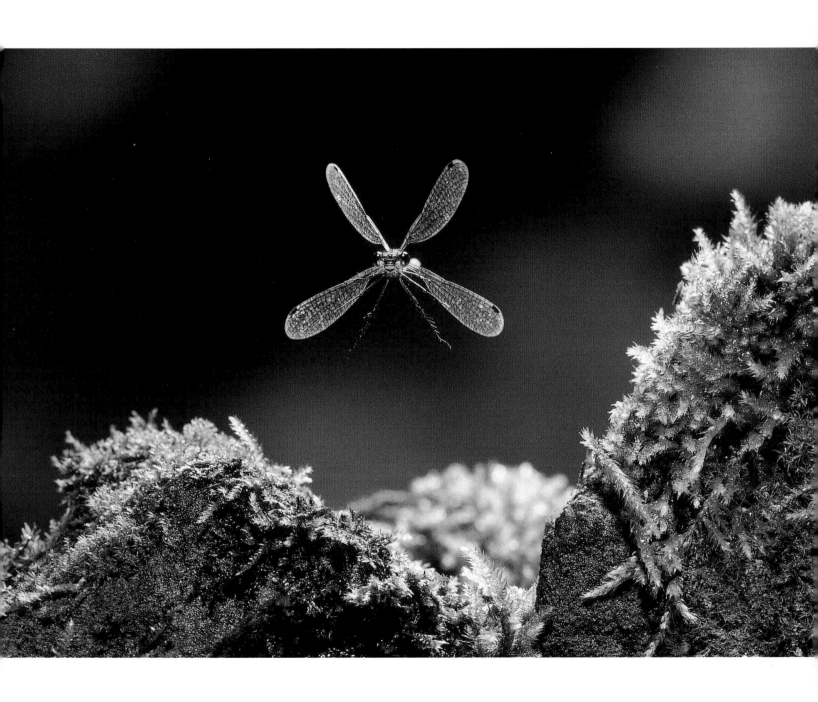

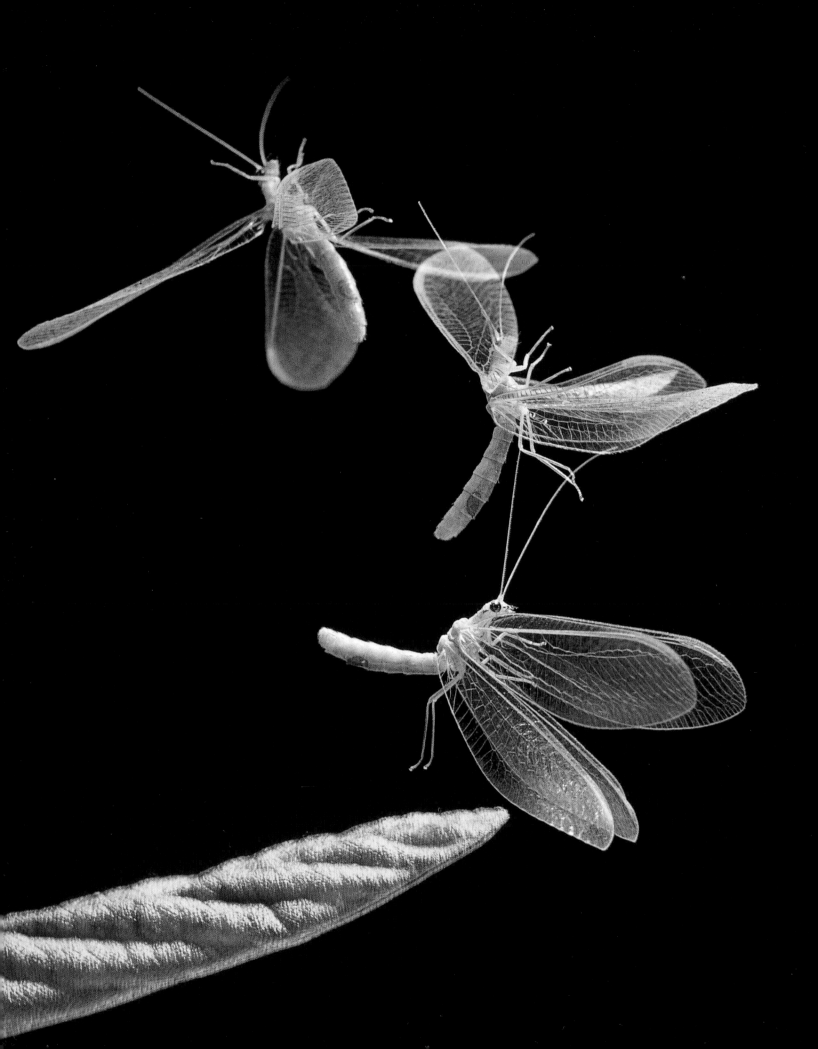

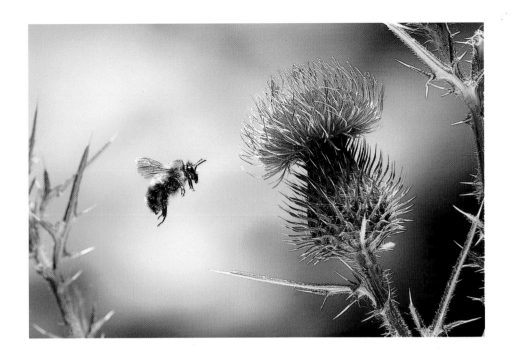

CARDER BUMBLEBEE (*Bombus agrorum*)

Many of us have an affection for bumblebees—perhaps we enjoy the soporific hum as they forage around us on a warm summer day, or maybe they remind us of miniature aerial teddy bears.

Bumblebees, such as this carder bee, were among the first insects I photographed on the wing, in the early 1970s. They could always be found in the garden on cold, wet, windy days, when all other insects had long ceased to fly.

GREEN LACEWING (*Chrysopa perla*)

The transparent wings, iridescent body and long threadlike antennae of the lacewing make it the epitome of aerial grace. No flying insect looks more fragile and delicate, yet the golden eyes and soft, pale wings of the slender green lacewing are only the external finery of a voracious and capable insect.

The weak, fluttering flight of this bewitching creature seems haphazard and uncontrolled, but my newly acquired multiflash revealed a more efficient reality. Although the lacewing appears to be at the mercy of the merest puff of wind, it is capable of extraordinary aerobatics, such as loops and backward somersaults, as I discovered after experimenting with hundreds of exposures. Why the lacewing engages in such maneuvers is not clear, but would-be predators almost certainly find these antics perplexing.

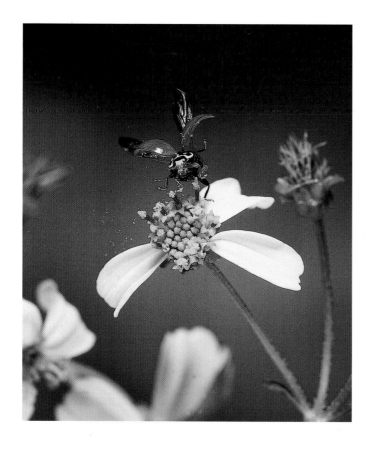

LADYBIRD (*Coccinella* sp)

An Everglades ladybird, or ladybug, leaves a shower of
yellow pollen as she begins her flight home. Over 4,000
identified species of these beetles, of which this red
variety is the most familiar, are spread around the world.
The species name of this one, like its neighbor the hawker
dragonfly, was never precisely determined.

HAWKER DRAGONFLY (*Aeshna* sp)

Another memorable spectacle from the Everglades was
this large, brown hawker dragonfly. Unfortunately, it was
impossible to identify the species accurately from the photo-
graph. Although not very active during the day, these beauti-
ful insects began a steady patrol of the woodland clearings as
dusk approached, hunting for mosquitoes. Sometimes, they
flew only a few feet off the ground, their thin chocolate-
brown bodies and amber-tinted wings merging with the
gloom. Only the faintest rustling of membranous wings in
the evening air betrayed their presence. In the fading light,
they flew higher and higher, dodging the gigantic webs
of golden orb spiders and weaving between the branches
of tall pines.

 After I netted a specimen and photographed it in the
flight tunnel, the dragonfly was returned unharmed to its
favorite haunt a few hours later.

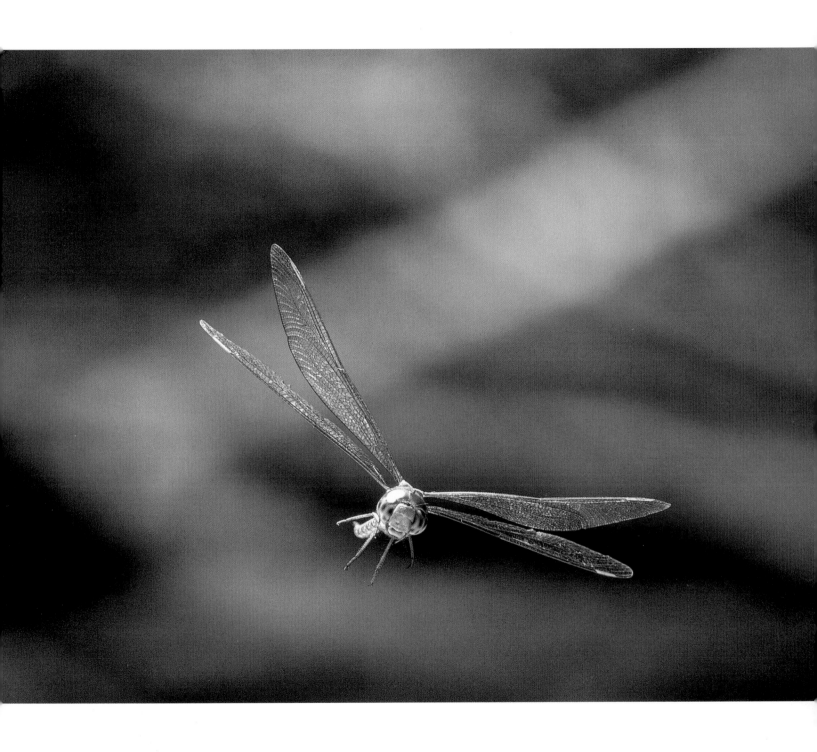

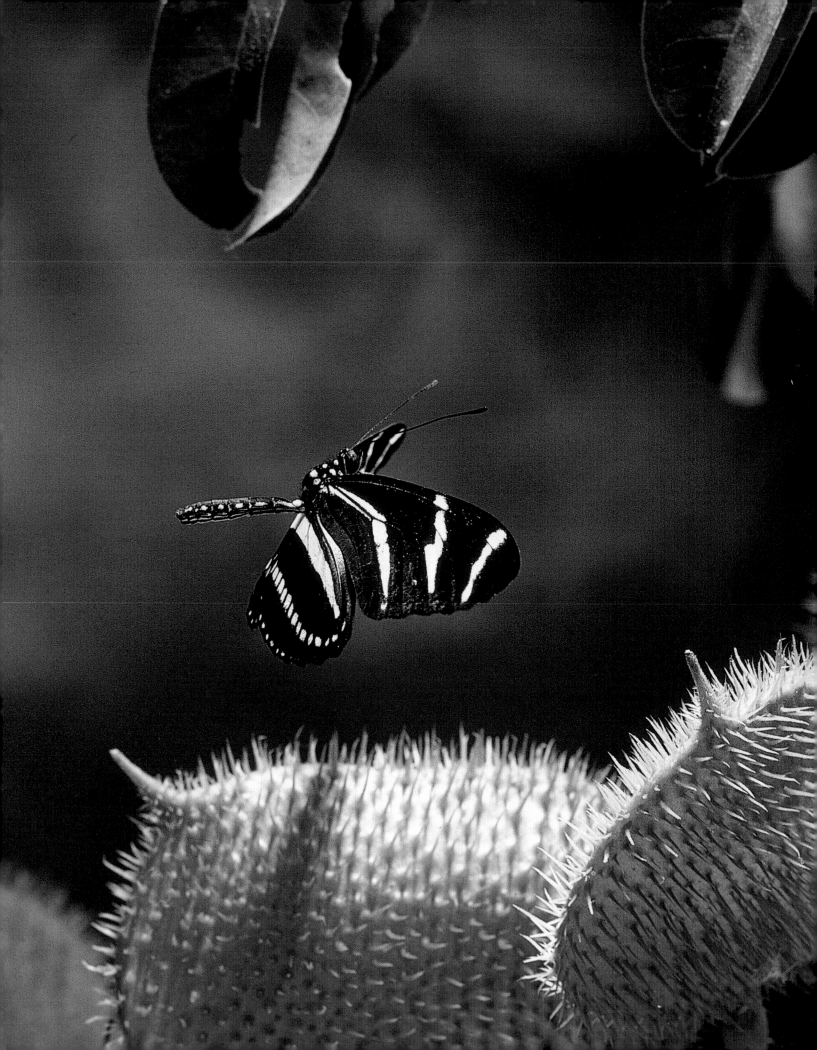

ZEBRA BUTTERFLY (*Heliconius charitonius*)

In 1974, I packed several crates with equipment and set off on my first assignment abroad: to photograph the unfamiliar and striking insects of the Florida Everglades.

Among the more exotic-looking specimens I encountered was the zebra butterfly, which belongs to the Heliconid group—a truly tropical family of butterflies that is often characterized by brilliant coloring and bold patterns. Only three species occur in North America, and these are confined to the south. The slow and fluttering shallow-wing-beat flight of the zebra makes it impossible to confuse this butterfly with any other species, and the sight of groups of zebras dancing above the mangrove swamps was enough to boost my spirits.

GREAT SPOTTED WOODPECKER
(*Dendrocopos major*)

After spending a year or two gaining experience with
insect-flight photography, the time seemed ripe to try
my techniques on other animals whose movements are
too fast to be seen with the naked eye. Birds were my first
new subjects, and here, the great spotted woodpecker
is caught diving out of its nest hole.

One of the chief problems when using high-speed
photography to capture creatures outdoors rather than
in the studio is that valuable equipment must be left out
for days or sometimes weeks on end at the mercy of
weather, vandals and thieves. Setting up typically has to
be done very gradually, so as not to upset the bird. Even
then, it can take days of fine-tuning before the best results
are potentially achievable. Such photography is therefore
restricted to remote private land well away from public
access—an increasingly difficult combination to find, espe-
cially in overcrowded England. As a result, I have done
little of this sort of work for several years.

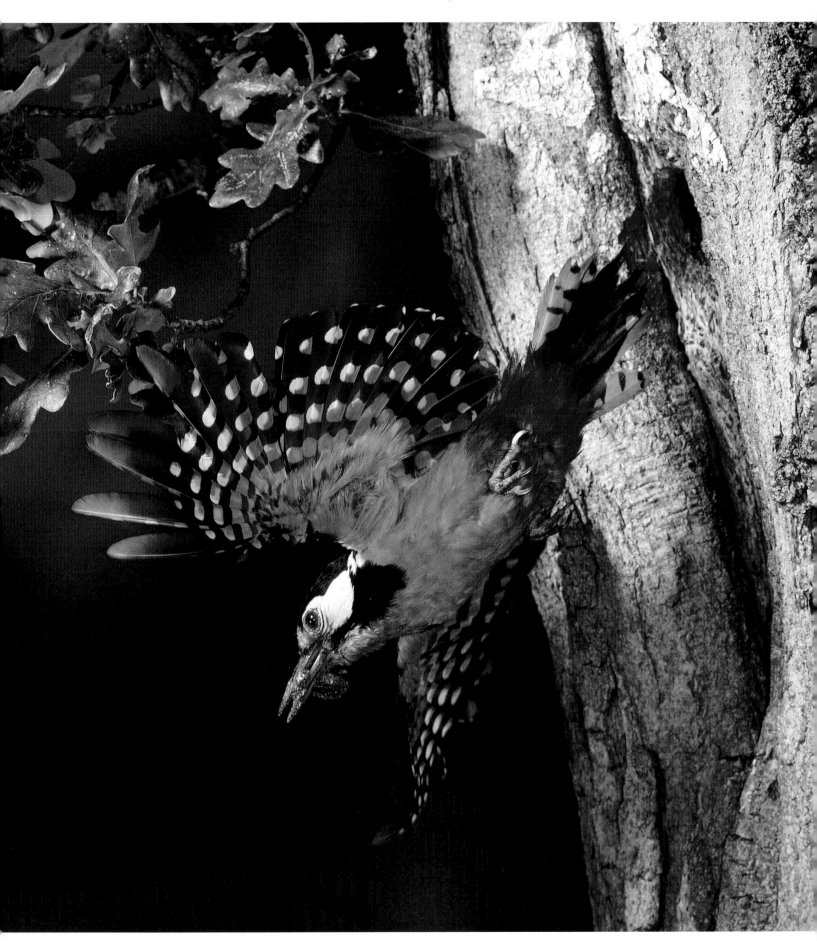

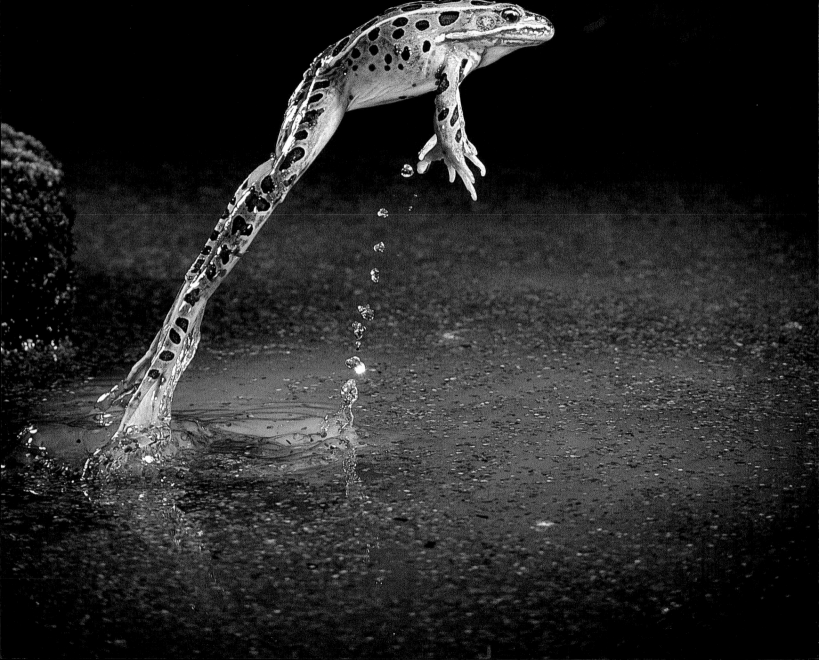

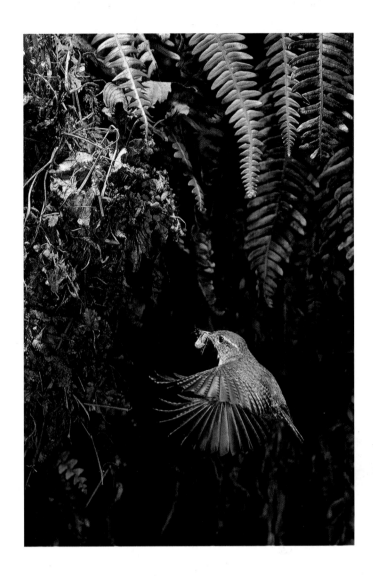

NORTHERN WREN (*Troglodytes troglodytes*)

The northern wren is a very amenable bird with which to work. This one was particularly cooperative, allowing me to sit on the bank of a stream within a yard or two of its nest, which I surrounded with a maze of cables, stands, lights and electronic gadgetry. I was able to complete the job within a day—a very unusual occurrence.

LEOPARD FROG (*Rana pipiens*)

Yet another area that had scarcely been explored with still photography by the late 1970s was the high-speed activities of reptiles and amphibians.

The leopard frog, the common frog of North America, is a much more enthusiastic leaper than the European species. The explosive power of the frog's hind legs is demonstrated as it vacates the shallows for the security of deeper water. It takes about one-tenth of a second for a frog to extend its legs fully, and the leap can propel the creature 12 times its own length.

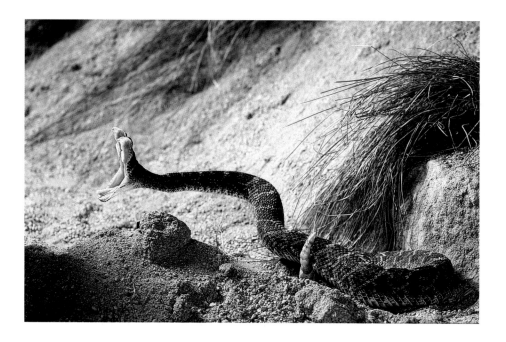

WESTERN DIAMONDBACK RATTLESNAKE
(*Crotalus atrox*)

One of my more hair-raising assignments was to photograph a western diamondback rattlesnake striking—an exercise I undertook not in the wilds of Texas but in a studio.

The snake was encouraged to strike at my surprisingly willing assistant, who held his bare hand just out of reach. Small beads of venom can be seen flowing from the erect hollow fangs.

Capturing this rapid action proved to be a sound test of my patience, as most snakes are reluctant to bite humans unless severely provoked. On the few occasions when this docile creature did strike, it rarely intercepted the two-millimeter light beam, necessitating a further long wait before the snake felt inclined to have another go.

BARN SWALLOW (*Hirundo rustica*)

Before my garden pond became surrounded by shrubs and trees, barn swallows would fly wide circuits around it, dipping into the water for an occasional drink on the wing. It was a splendid sight, one too tempting to ignore photographically.

I erected tripods, flash units and a profusion of photographic and electronic equipment all around the pond—this was undertaken over a couple of weeks, so as not to frighten away the birds (there were plenty of other places for them to drink). Because of the speed of the bird, shutter delay had to be compensated for by focusing the camera some 10 inches in front of the plane of the light beam. It was also necessary to soundproof the noisy camera.

After a week of test exposures, when all the adjustments to the lighting and timing were finely tuned, I set about taking a series of photographs that showed the bird skimming gracefully over the water's surface and scooping water into its beak. Sometimes, the bird would approach the pond at a much steeper angle and dive in for a bath, emerging a second later with a dramatic splash, not unlike an aquatic jack-in-the-box.

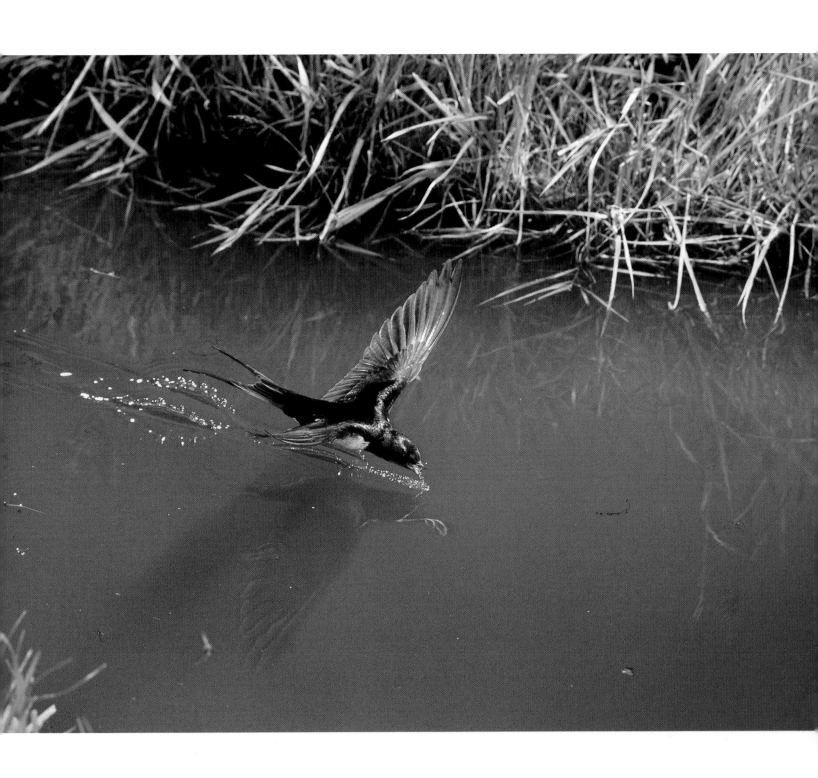

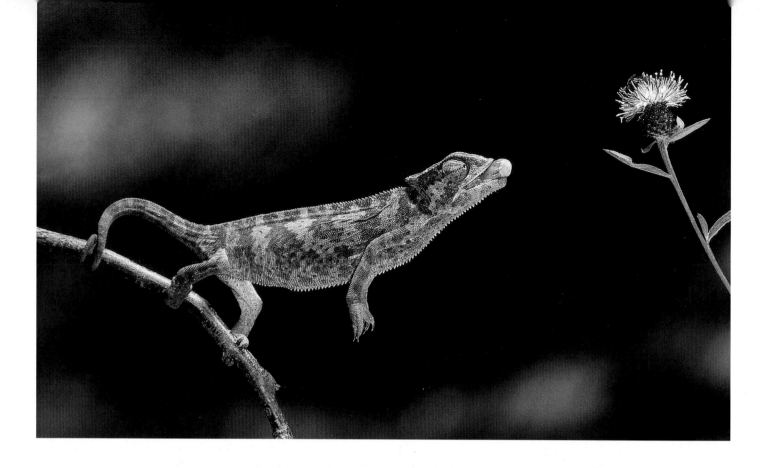

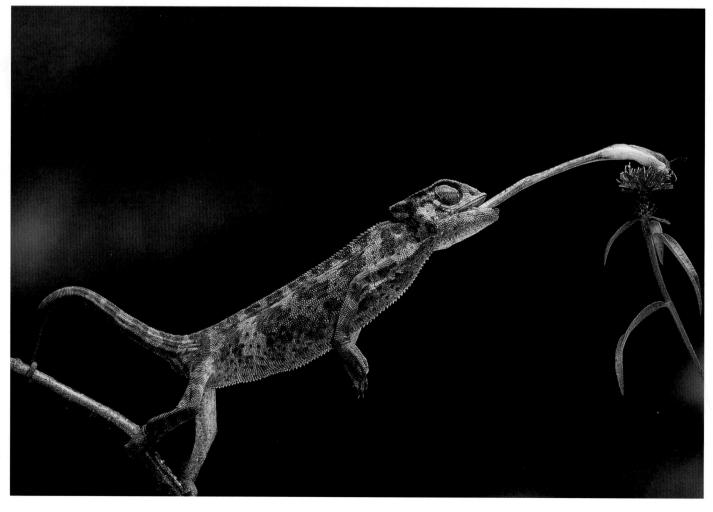

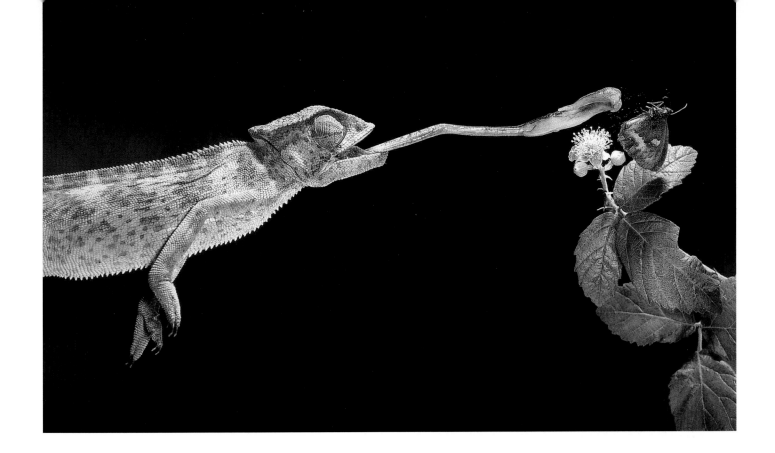

MEDITERRANEAN CHAMELEON
(*Chamaeleo chamaeleon*)

Nature's ingenuity seems limitless, and the chameleon has more than its fair share of special attributes. In addition to its renowned ability to change color within seconds, the chameleon can also look in more than one direction at the same time, since each of its eyes can swivel independently about 180 degrees in any direction. The animal waits, camouflaged and motionless, until an insect comes within range of its long tongue. At the moment of attack, both eyes are directed forward to provide the stereoscopic vision necessary for an accurate strike. The chameleon's tongue can be extended to about twice the length of its body, and as contact is made, the victim is held fast by the tongue's sticky tip, although photographs reveal that the tip also grasps the prey.

The Mediterranean chameleon is found throughout most of the Mediterranean countries and northern Africa, but in many areas, it is declining quickly as a result of habitat loss.

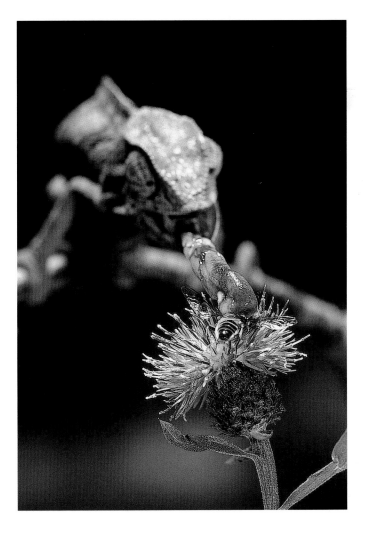

FALSE VAMPIRE (*Megaderma lyra*)

I usually turn down commissioned work, but when an international magazine invited me to photograph various types of bats hunting on the wing, it was a challenge I could not refuse. It was also one that would take me to Germany, New York, Venezuela and New Mexico.

One of the bats selected to illustrate the range of bat-hunting techniques was the false vampire, a large predatory bat native to India. In the wild, this bat leaves its daytime roost in caves and skims over the ground hunting for frogs and mice. As I did not relish the idea of having to squeeze into bug-infested claustrophobic caves knee-deep in bat droppings, I chose to work with captive bats in the relative comfort of Frankfurt University, where a team of scientists was conducting research on echolocation.

The bats were being kept in an abandoned underground bowling alley in the middle of the city. Watching this curious mammal as it searched for mice was a fascinating experience. It began hunting passively, like a barn owl, flying a few feet above the ground, its head and ears directed downward, listening for rustles and other mouselike sounds. If a mouse moved so much as a whisker, it was doomed. The bat's incredibly sensitive ears would pinpoint the sound, allowing it to home in accurately from 20 to 30 feet away. Then the bat would use its echolocation system for the first time, hovering briefly above its prey to get a precise fix—the pulse was audible to humans—before dropping down and seizing the creature by the scruff of its neck to be carried away and devoured at leisure.

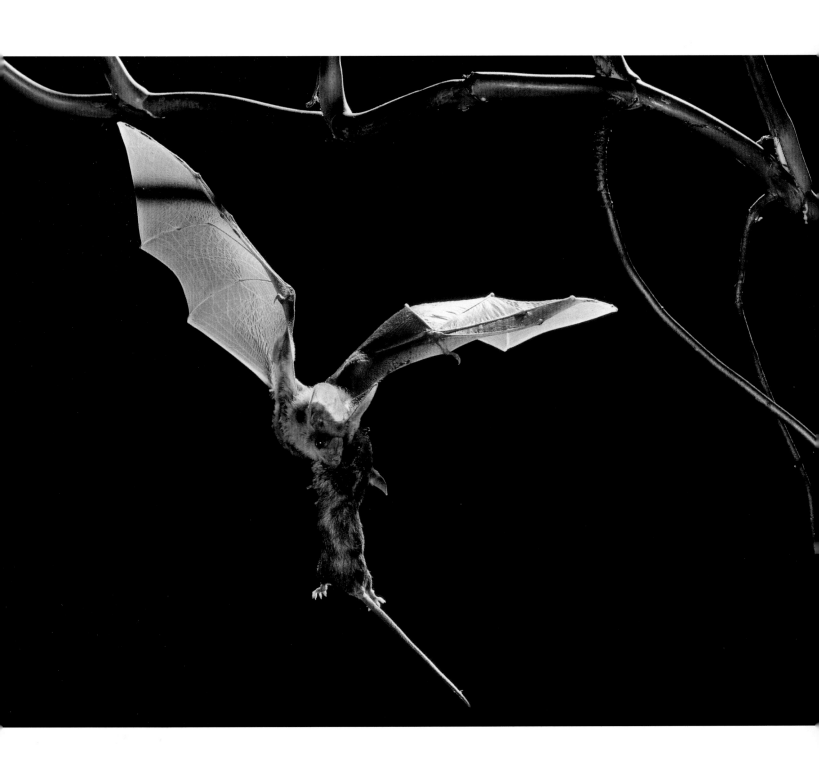

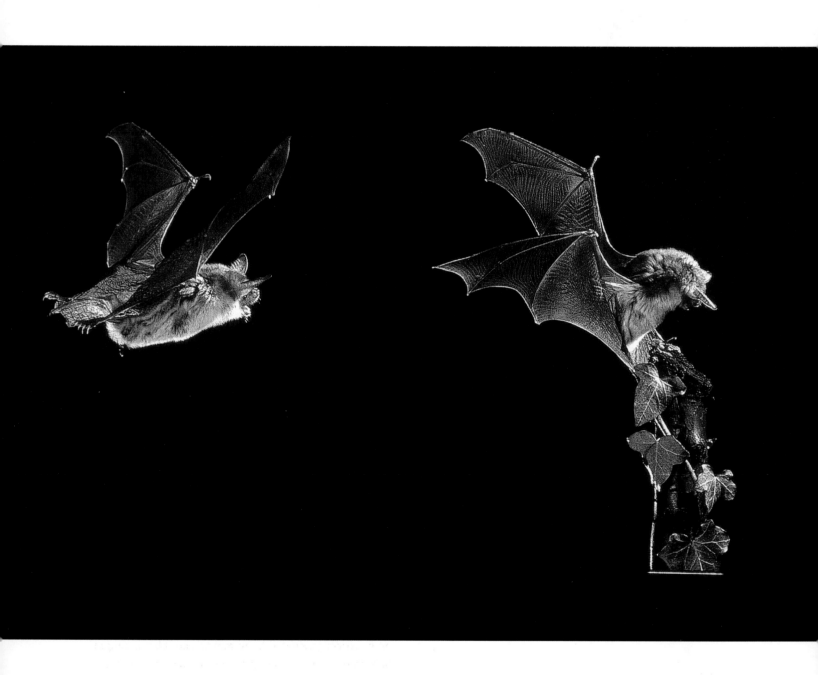

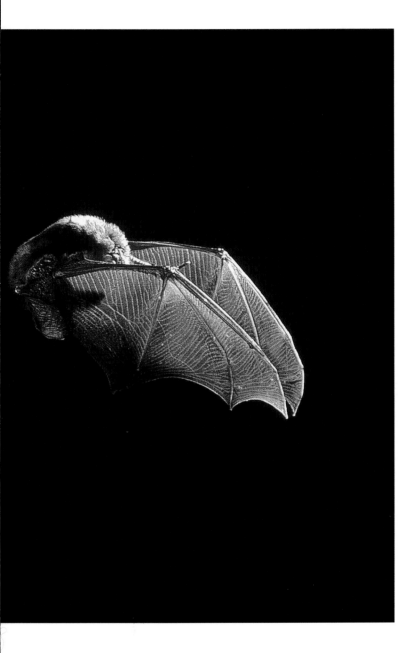

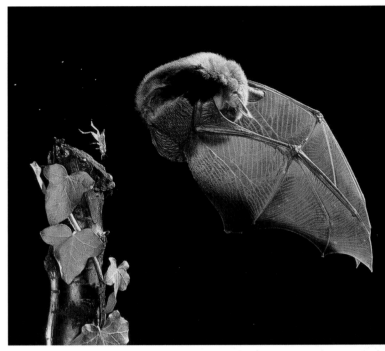

MOUSE-EARED BAT (*Myotis myotis*)

Now extinct in England, the mouse-eared bat is caught here in three postures as it homes in on a cricket on a stump. During its approach, the bat opens its mouth and emits a series of ultrasonic squeaks. It will then sweep up its victim in its tail pouch and, without delay, curl its flexible body to collect the morsel in its mouth.

In the last picture in the sequence, however, the bat has missed the cricket, which has been sent flying through the air. As normal multiflash would have been impossible because of the nonmoving stump, these photographs were exposed as a series of three.

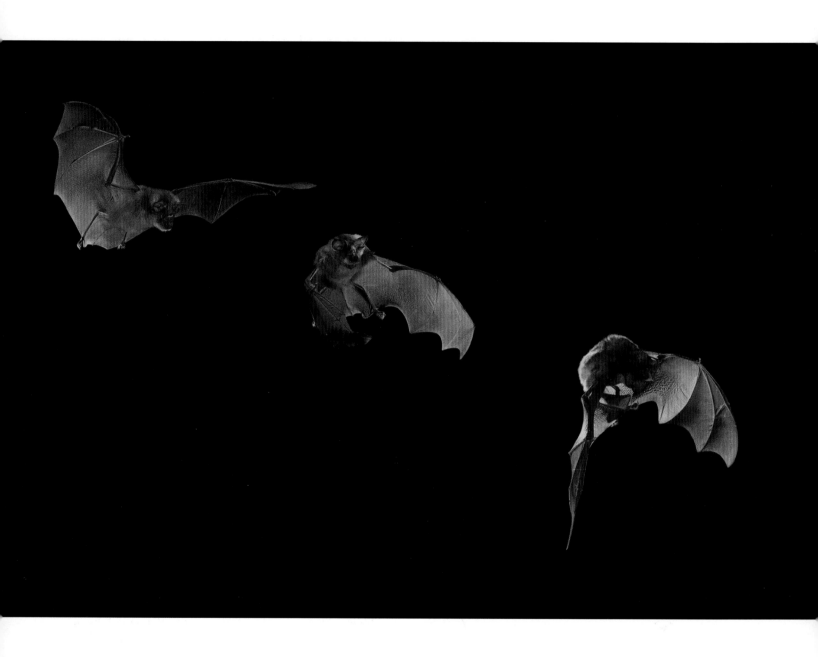

HORSESHOE BAT (*Rhinolophus ferrum-equinum*)

Since the vast majority of bats catch insects on the wing, it was vital to record this event in a photograph. It is one thing to photograph insects or bats in flight by themselves but quite another to get both together in the same spot. Fortunately, some experience gained a few years earlier when working with pipistrelle bats stood me in good stead in eventually realizing this goal. I decided to visit Frankfurt University, where Professor Gerhardt Neuweiler and his team were conducting research on echolocation using horseshoe bats, a species now virtually extinct in Britain.

One trick was to train the bat to engage the moth within a limited plane of about six inches—the bat was hanging in a corner of a 20-foot-square underground enclosure. I began by lobbing mealworms into the air. Bats are quick to learn, and within a few days, this one was catching the "flying" larvae almost every time, dropping down from its roosting perch as soon as my hand started to flick forward. In doing so, this bright little animal managed to cover half the distance to its prey—some two yards—before the mealworm had actually left my fingers. The speed at which all this took place was uncanny.

The most unforgettable aspect of this exercise occurred when the mealworms were replaced with live moths. Twisting and turning in the air in its pursuit of the moths, this fascinating mammal performed aerial maneuvers with a speed and precision that even a hummingbird might regard with awe—and all of this took place in nearly total darkness.

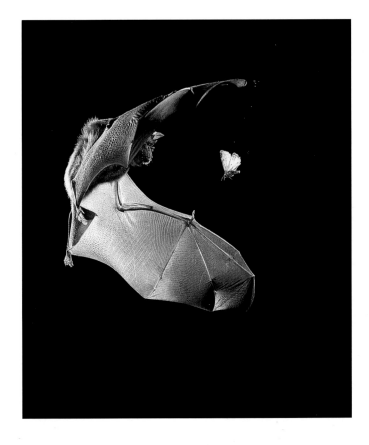

The horseshoe bat has evolved an extremely advanced and deadly accurate echolocation system based on the Doppler effect, which enables the creature to assess both the speed and the angle of its fast-moving prey. It does this by first emitting a long pulse of constant frequency, then detecting the minute shift in apparent frequency of the echo resulting from the relative speed and direction of the moth. By adjusting the frequency of its cry and altering its flight path, the bat can home in on any flying insect. The third image of the multiflash shows the creature arching forward to collect the moth caught in its tail pouch.

When the work was completed, I returned home, marveling once more at the beauty of the evolutionary processes that have made such refined animal behavior possible.

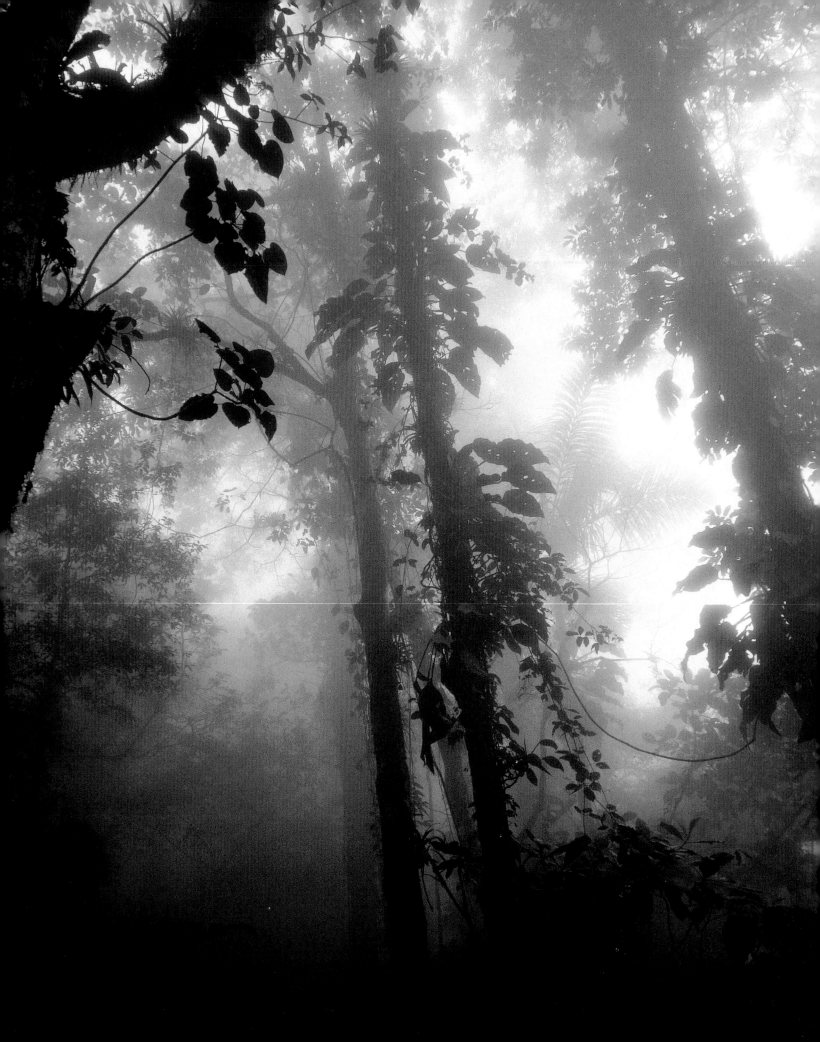

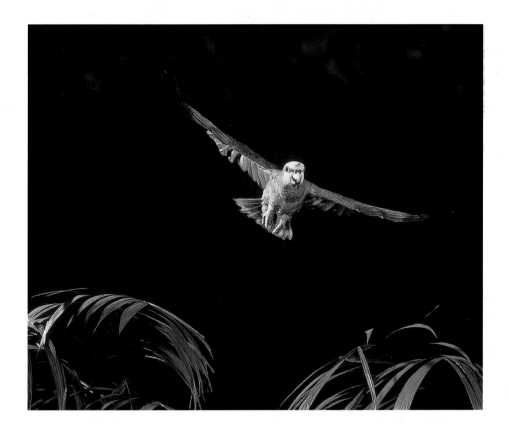

ORANGE-WINGED AMAZON PARROT
(*Amazona amazonica*)

Another engaging experience of the tropical forest is the sound and sight of parrots and macaws. These gregarious birds are highly intelligent, and the forests in which they spend their lives resound with their chattering and shrieking calls and are brightened by their gay colors.

The orange-winged amazon is one of the 25 or so *Amazona* species of parrots that inhabit the lowland rainforests of the Amazon basin, where it spends much of its time in the canopy feeding on fruit, seeds and nuts.

CLOUD FOREST IN MIST

Many of these rainforest photographs were taken on two short visits to the highlands of Venezuela at the end of the 1970s. My main goal was to photograph some of the exotic flying insects that abound in this vanishing paradise—this picture was exposed in the area where most of the creatures seen here led their lives.

In the early morning and evening and often at odd times during the day, the clouds descended from the mountains, shrouding the forest in a cold, thick but life-giving mist and saturating everything with which it came into contact. Tropical rainforests and cloud forests represent the pinnacle of advanced ecosystems and are, simply by virtue of the intoxicating variety of life they support, among the most beautiful places on Earth. Nothing is more important than saving them.

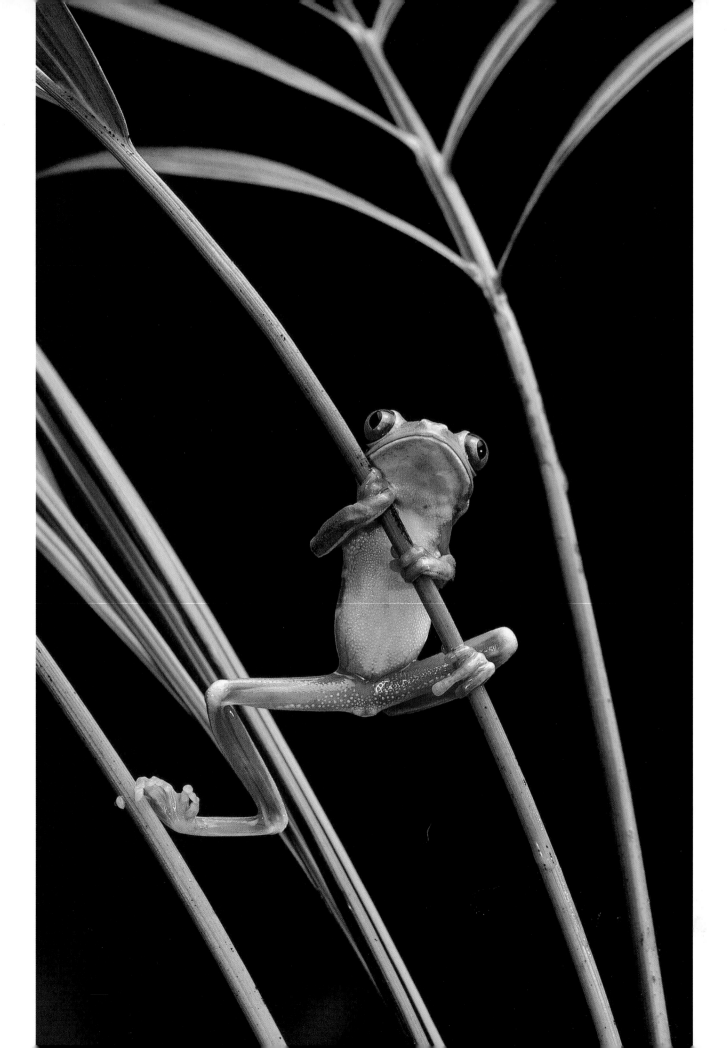

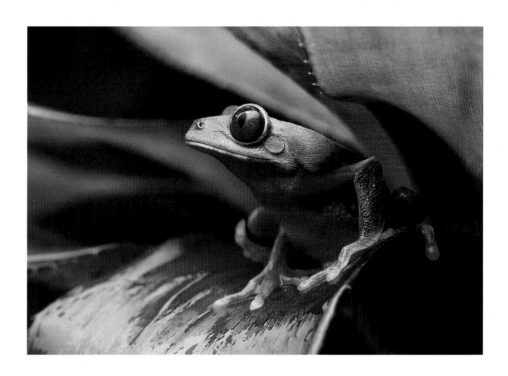

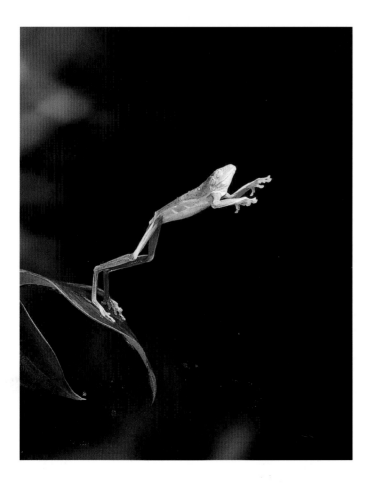

RED-EYED TREE FROG (*Agalychnis callidryas*)

The red-eyed tree frog lives in the tropical rainforests of Central and South America. It is hardly surprising that this most appealing of cold-blooded creatures, with its large red eyes and perpetually grinning face, is also one of the most frequently photographed. The tree frog feeds chiefly on insects and other small invertebrates, most of which are found on leaves and stems, but at times, a more active hunting technique is required. After gauging the angle and distance of its potential prey, the frog retracts its eyes for protection, then leaps.

Many tree frog species are brightly colored and move by day under the protection of warning coloration. Others, such as the red-eyed tree frog, are well camouflaged and spend the daylight hours lying immobile and flat on a leaf or inside the curled leaves of a bromeliad. At night, these frogs wake up to join in the glorious nocturnal chorus with crickets and grasshoppers.

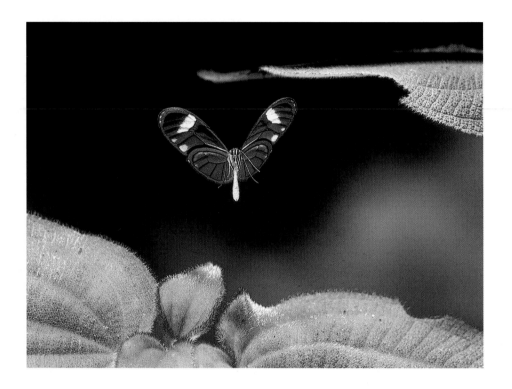

SKELETON BUTTERFLY (*Pteronymia* sp)
GREEN HELICONID (*Phylaethria dido*)

Among the most enchanting inhabitants of cloud forests are the butterflies, particularly the ithomids and heliconids, which appear as if by magic in the small patches of sunlight that break through the forest canopy. These two families are considered to be among the most highly evolved groups of butterflies and are characterized by their slow, fluttering flight.

As they generally have unpleasant odors and body juices and may exhibit bright colors and bold patterns, these butterflies are well protected from predators. They are limited to the tropical regions of the New World and are noted for their mimicry of other species: Their shallow wing beats help to flaunt their distinctive wing patterns. Both groups are Müllerian mimics (Fritz Müller was a 19th-century German naturalist who theorized that these poisonous insects evolved to resemble one another and thereby give like signals of distastefulness to would-be predators).

The most memorable butterfly of the Venezuelan cloud forest was this green heliconid, right. No amount of refined photography or subtle lighting could do justice to the delicate shades of green and silver that adorned the wings of this exquisite insect. Ithomids and heliconids are often extremely difficult to tell apart. Some, such as the skeleton butterfly, above, have clear wings that help them remain invisible in the subdued and dappled light of the understory.

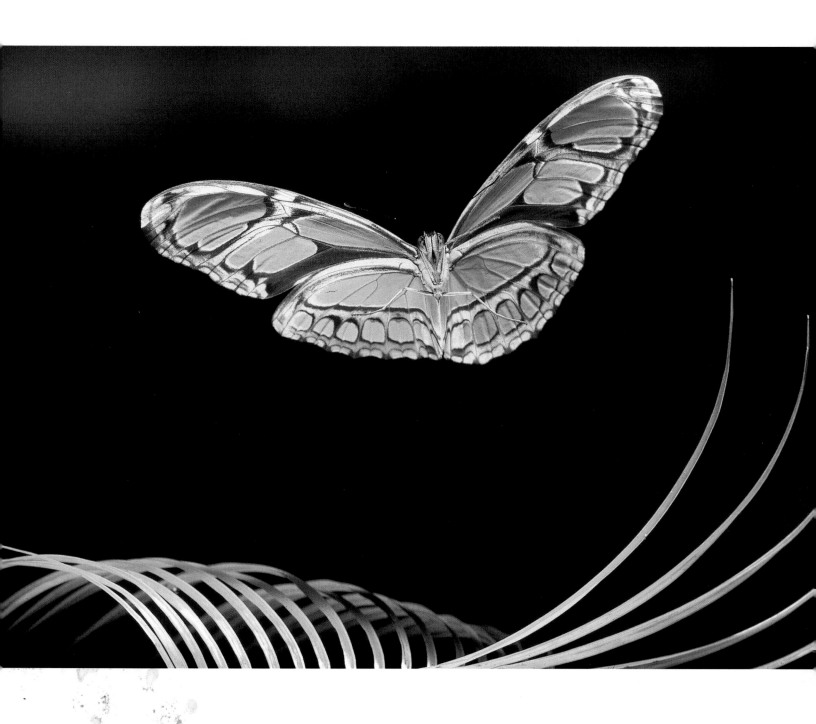

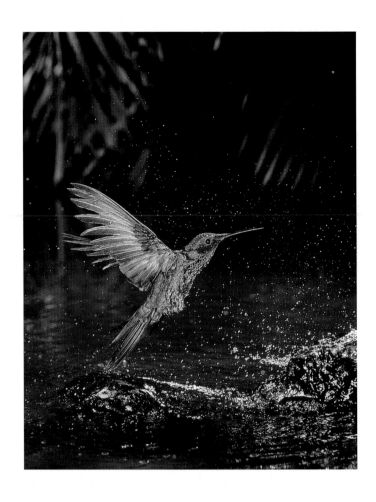

GREEN VIOLET-EAR (*Colibri thalassinus*)

What hummingbirds lack in size, they more than compensate for with their dazzling colors and utter mastery of the air. There are over 300 species of these diminutive birds, most of which inhabit South America, although a handful are found in North America.

In spite of their small size and delicate appearance, hummingbirds are constitutionally tough birds. Some species are able to withstand subzero temperatures and altitudes of up to 5,000 feet, where the air is thin and low in oxygen. Others migrate vast distances—one species undertakes the incredible journey to and from Alaska and Central America every year.

To blur the wings and evoke the feeling of hovering, one of the photographs was exposed with a relatively long flash of about 1/3,000 second, but a much faster flash speed of around 1/25,000 second was used to freeze the water droplets of the bird bathing, a vision I frequently encountered while wandering up the mountain streams.

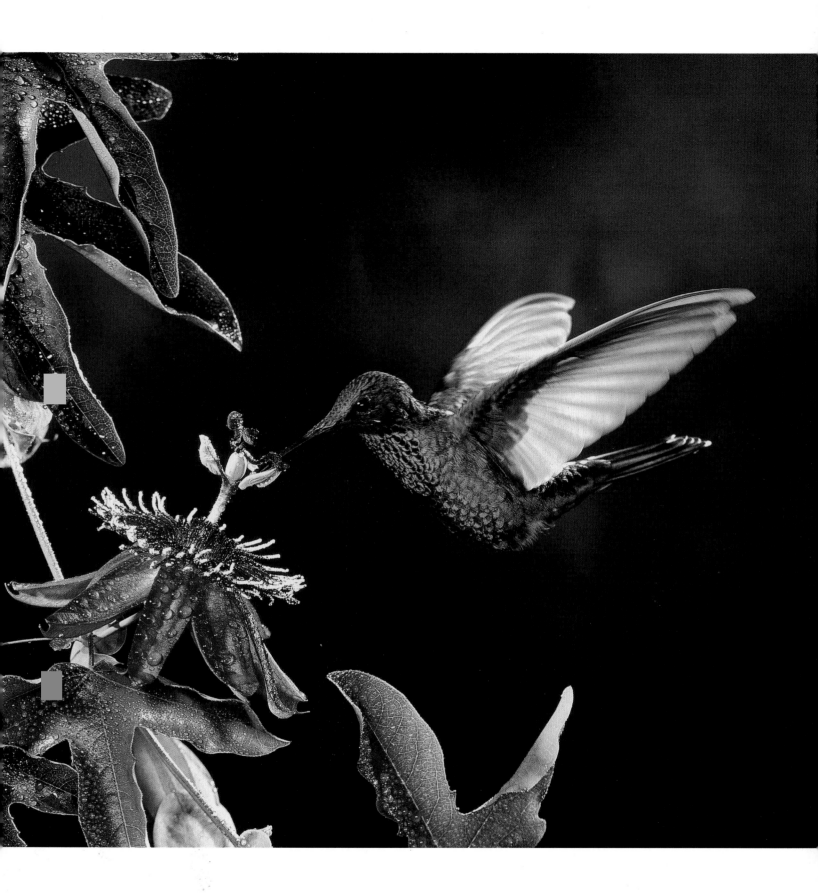

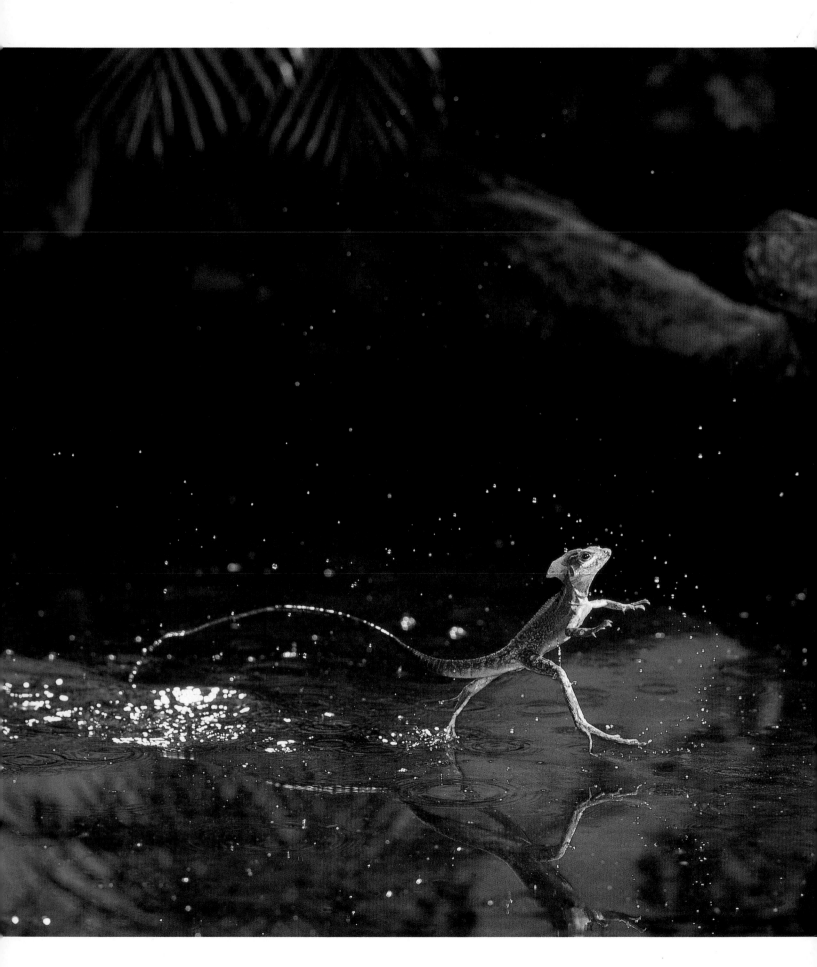

BASILISK (*Basiliscus basiliscus*)

Few sights in the rainforest are more astonishing than that of a large dinosaurlike lizard racing across the surface of a river or pool. But the brown basilisk, or Jesus lizard, as it is sometimes called, has evolved the extraordinary ability to run on water without sinking. At one time, nobody had any sound idea of how the phenomenon was achieved, since the creature does not possess webbed feet.

This photograph, the result of a three-week struggle, is the first time the performance has been recorded with a still camera. The effort was worthwhile, because the image inspired two scientists at Harvard (Dr. James Glasheen and Dr. Thomas McMahon) to investigate this apparently gravity-defying act.

Insects that stand on or skim across the water are supported by the water's surface-tension forces. It would take too long to describe in detail here how the basilisk stays atop the water, but suffice it to say that when the creature's feet touch the surface, the ensuing downward and backward stroke creates an air-filled potholelike cavity from which the feet are rapidly withdrawn before the cavity fills in.

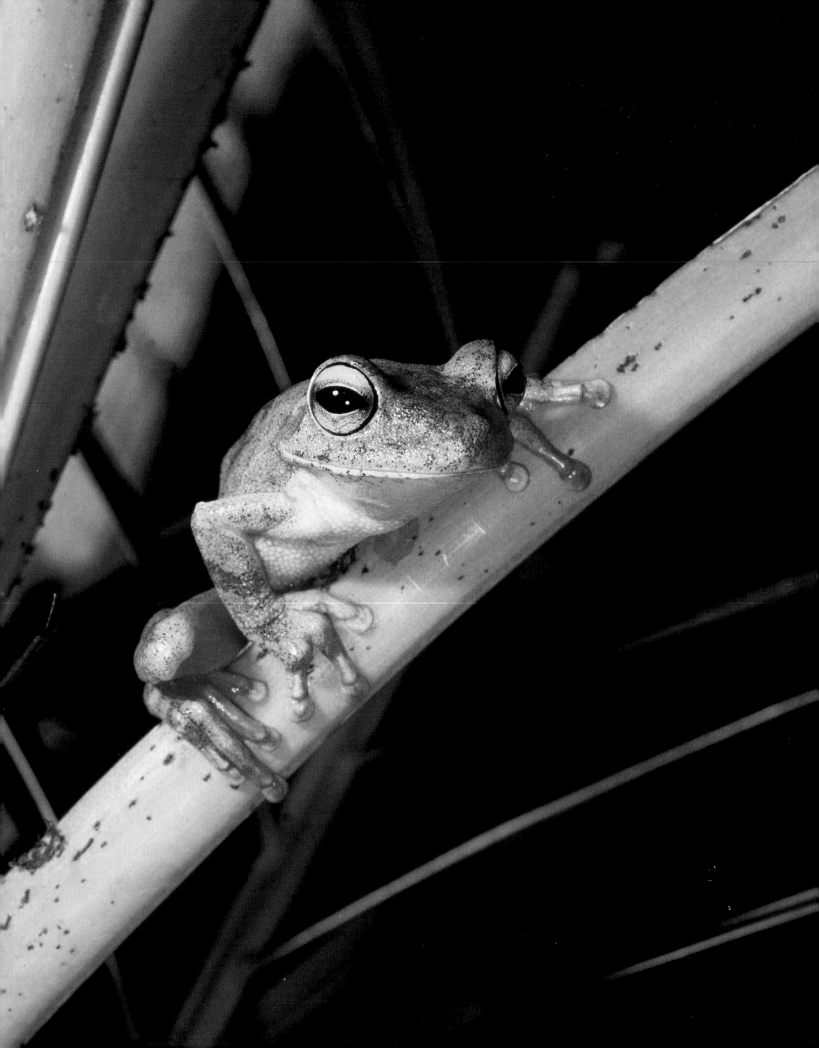

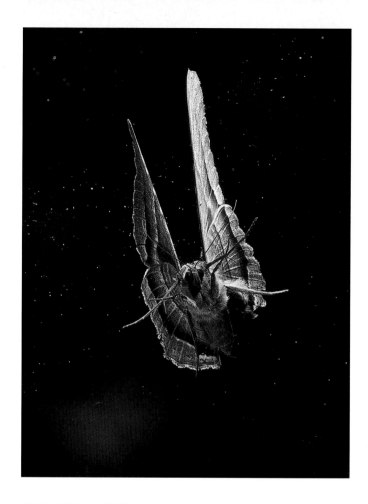

BLACK WITCH MOTH (*Ascalapha odorata*)

It is difficult to believe that the black witch moth, with its eight-inch wingspan, belongs to the same family as our modestly proportioned noctuids, or owlet moths—the often dull brown or gray moths that enter our houses.

Found in a Venezuelan cloud forest, this huge moth was persuaded to fly in the confines of a flight tunnel originally designed for much smaller insects. The white specks are scales that were shed during a frenzied takeoff.

TREE FROG (*Hyla* sp)

Among the hundreds of tree frog species, the majority are nocturnal. This one has spent the day resting on a palm stem, attached by means of suckers on the ends of its toes. The suckers enable the frog to move around the foliage by jumping from one leaf to another, sometimes catching hold with only one foot.

Whereas most of my photographs take hours, days or sometimes weeks to prepare and shoot, this one took only a few minutes to complete, after I came upon the frog while exploring a path at the forest edge.

Woodland and Waterside

Forests of one kind or another, especially those with open areas and diverse habitats, have always been a favorite haunt of mine, both because they are quiet places away from the more obvious signs of human activity and because of the life they support. They help to regenerate flagging spirits.

The eighties marked the publication of several of my books, two of which were based around a local oakwood. The main object of the first, *The Secret Life of an Oakwood*, was to evoke some of the atmosphere of the oakwood and to show its seasonal cycle of life. I chose an area of woodland surrounding an attractive and natural-looking reservoir near my home. Here, the animal and plant life was enhanced by the three-quarter-mile-long stretch of water and the numerous streams and boggy places within the woodland's boundaries.

Many pleasant hours were spent wandering around looking for suitable material: flowers, fungi, mosses and woodland debris. Such subjects generally need little planning and involve a very low-key approach to nature photography. Adding to the area's appeal was the lack of searing temperatures, biting winds and dangerous animals—and of course, my home was less than a mile away. As it happened, it was quite easy to drift about for a whole day without taking a single picture. The more ambitious sessions, however, made up for these relaxed interludes. Capturing the badger on film, for instance, demanded an enormous amount of time and caused a great deal of frustration, as did the challenging high-speed photography conducted both in the field and in the studio.

After a couple of seasons of photographic activity, I discovered such a profusion of animals and plant life in this same location that I had sufficient material to illustrate another book, *At the Water's Edge*. A selection of the waterside pictures is included in the second half of this chapter, but we start out boldly with a small assortment of frogs, spiders, rats and fleas, perhaps not the most popular of creatures yet possessing a certain charm and fascination of their own.

JUMPING SPIDER (*Plexippus paykulli*)

Even though I have a horror of large, fast spiders, I find them compelling creatures. The jumping spiders of the Salticidae family are an especially intriguing group to watch and photograph. Rather than relying on the web vibrations of struggling insects to find its prey, a jumping spider uses its large, sensitive eyes to locate dinner, leaping on its victims from some distance.

Plexippus paykulli, the species illustrated here, shared a hotel room with me while I was on holiday in Crete and is found throughout much of Africa and the Mediterranean.

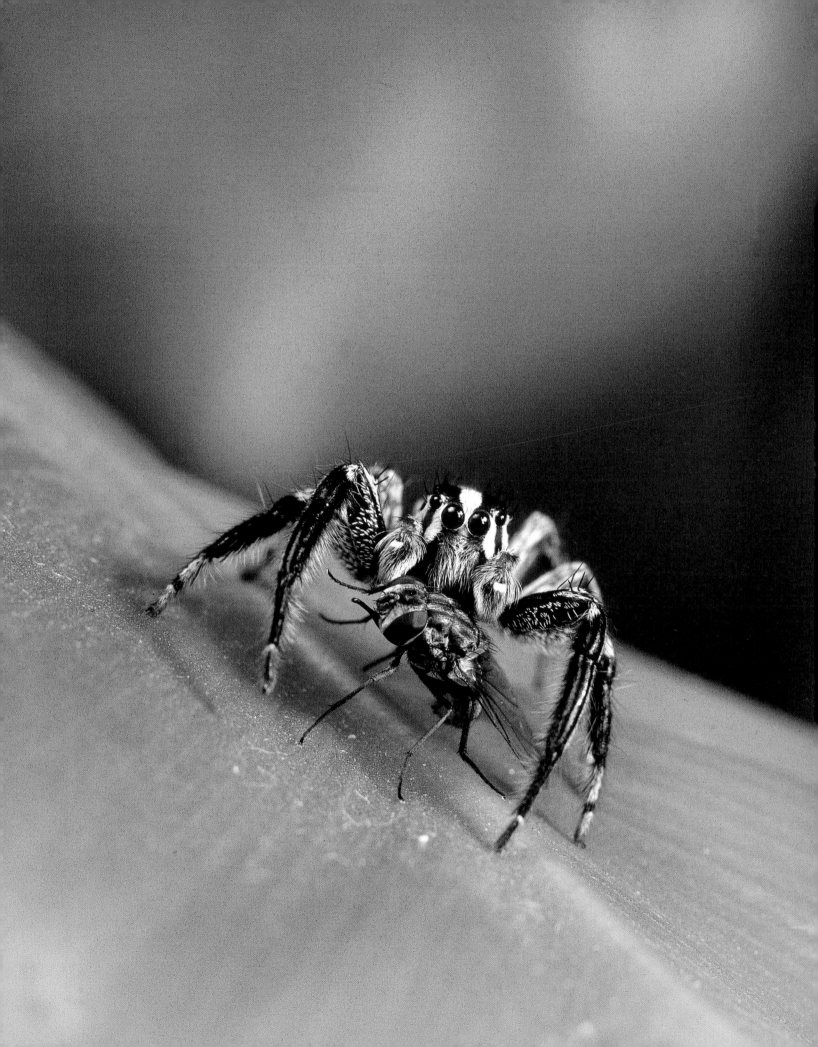

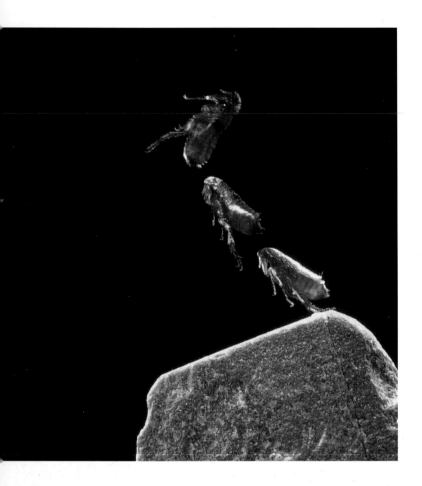

CAT FLEA (*Ctenocephalides felis*)

The leaping powers of a flea are prodigious. Equipped with modified flight muscles (the flea's ancestors were winged insects), the hind legs can rocket the little creature to 150 times its height. In fact, the acceleration forces are so great (300 g's) that scientists were once baffled as to how the insect avoids breaking its legs on takeoff. It was later discovered that rather than using its feet, the flea launches itself from its much thicker knees.

This photograph was commissioned by *National Geographic* magazine to show exactly how the flea's launch is initiated. My first reaction to the proposed assignment was to refuse, since capturing the flea in midjump was clearly going to demand a great deal of time and effort, with very uncertain results. After a few days of reflection, however, I accepted the challenge. Just as I had expected, there were enormous difficulties, and the whole operation stretched over many weeks.

After finding the local veterinary clinic to be a suitable source of fleas, I then had to devise a satisfactory technique for handling the tiny, highly mobile insects in my home. To freeze the rapid movement during acceleration, the flash units had to be modified to produce at least 1/60,000 second, three times their normal speed. As it turned out, even that was not really fast enough.

Naturally, timing was critical and required that the optics of the trigger system be refined and then meticulously adjusted to capture the start of the takeoff. Other technical difficulties centered around the very narrow depth of field one has when photographing such a small subject. To get an acceptably sharp image, the fleas had to jump at right angles to the lens axis within a one-millimeter plane. And encouraging the creatures to jump at all was another story. In spite of all the elaborate electronic gadgetry, the operation had to be conducted with the help of both hands, feet and mouth in almost total darkness.

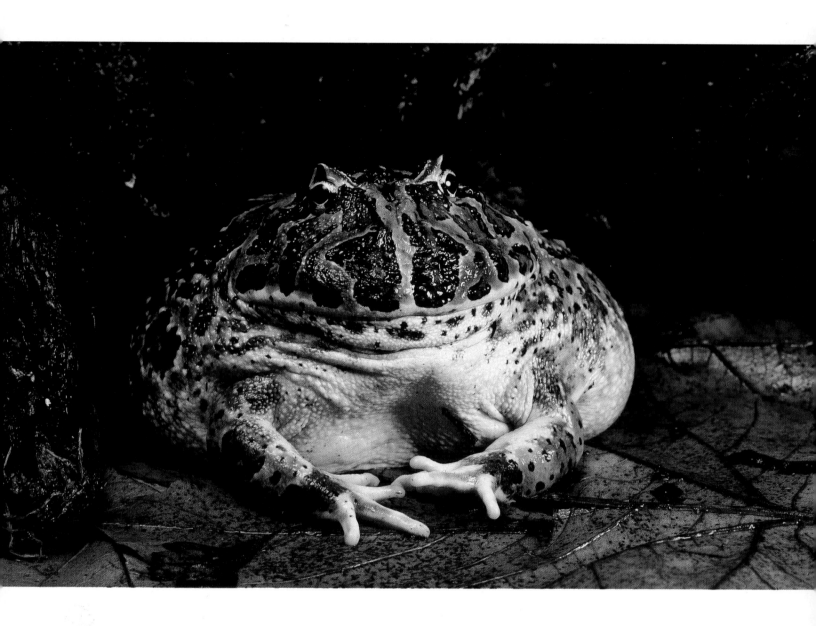

HORNED FROG (*Ceratophrys ornata*)

Do not be deceived by the sweet, smiling expression of this striking amphibian. An adult horned frog is almost the size of a dinner plate and has a pugnacious disposition. This South American native feeds on small mammals, birds, snakes and other frog species and is even reputed to be cannibalistic.

Lying half-buried in the ground, the horned frog waits for unsuspecting prey to pass by. When it does, the frog suddenly leaps from its hiding place and seizes its victim.

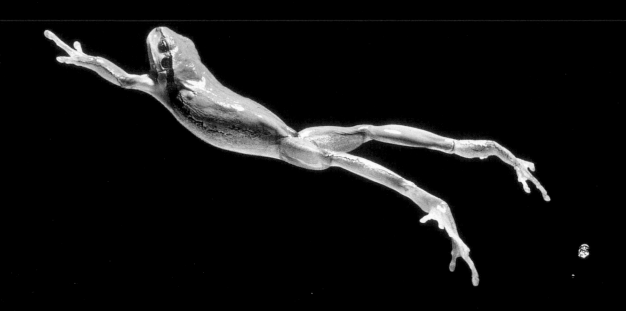

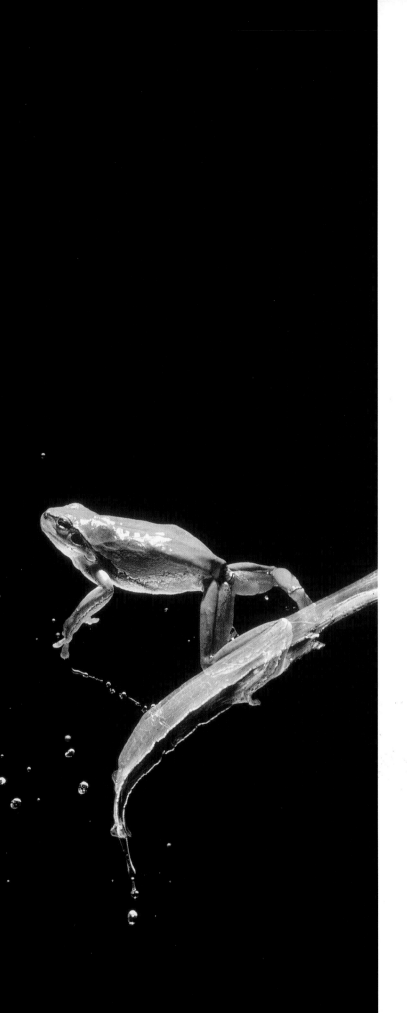

EUROPEAN TREE FROG (*Hyla arboria*)

Two stages of takeoff are recorded here as a European tree frog leaps from a wet leaf. A tree frog will jump to avoid a predator or to catch prey, but before doing so, it carefully gauges the exact distance to its intended landing point. As it launches itself into the air, the frog contracts its eyes into the sockets for protection, so in effect, it is "jumping blind," as this photograph illustrates.

BROWN RAT (*Rattus norvegicus*)

The central reason for the success of the brown rat is its adaptive lifestyle: It seems equally happy living around farms and warehouses as it does alongside riverbanks and in sewers.

One of my self-appointed assignments was to photograph these animals in a wide range of habitats. To do so, I was compelled to keep a number of brown rats in my home. Before long, my entire family was totally captivated by their endearing qualities. Although when present in large numbers, rats can be a nuisance and spread disease, they are, as individuals, great characters and make clean, lovable pets.

Brown rats are enthusiastic swimmers, and after exploring a land drain to its end, "Ratty" here contemplates a plunge into the pool beyond.

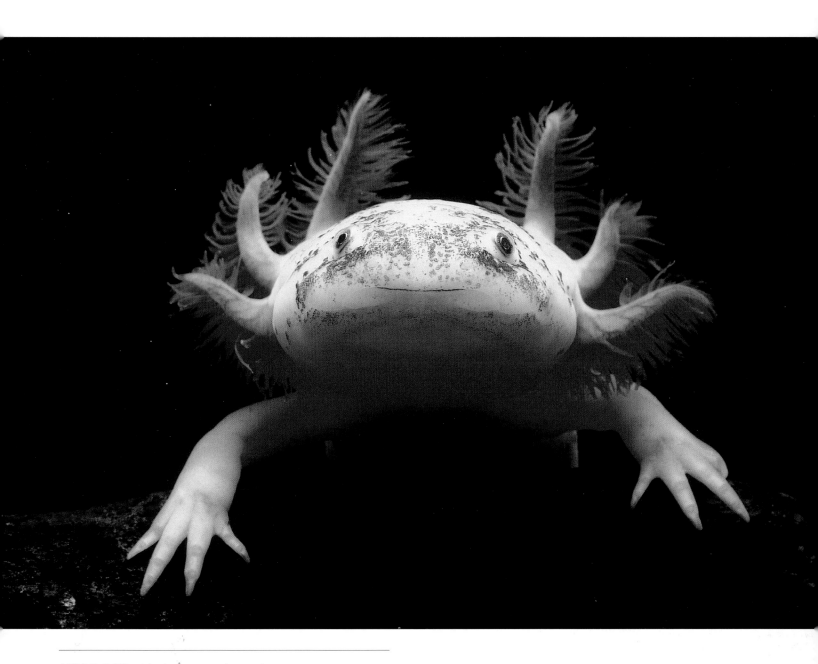

AXOLOTL (*Ambystoma mexicanum*)

This engaging face belongs to an axolotl, a large Mexican salamander that reaches sexual maturity without losing its gills—remaining, for all intents and purposes, a giant tadpole. Neoteny, as this unusual phenomenon is called, can occur in a number of species of newts, typically where the water is cold or deep. It is also associated with albinism, as in this case.

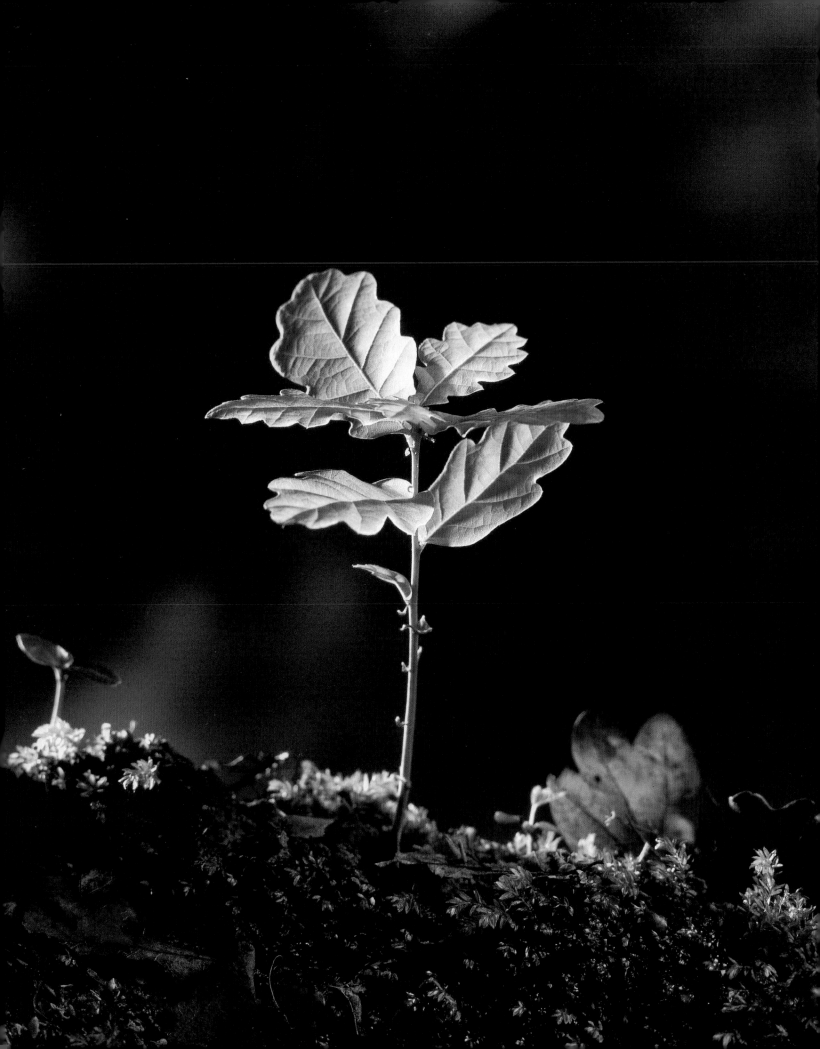

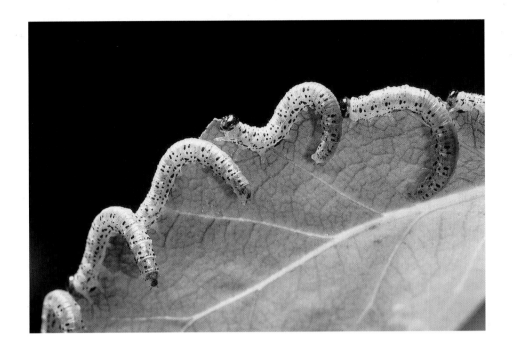

POPLAR SAWFLY (*Cladius viminalis*)

Sawfly larvae resemble the larvae of butterflies and moths, but they feed even more prolifically, boring into buds, flowers, fruit, wood and leaves, sometimes stripping branches or whole bushes of their foliage. Typically, the larvae feed in regimented groups, as seen here in the poplar sawfly. Not a fly at all, the sawfly is closely related to bees and wasps.

OAK SEEDLING (*Quercus robur*)

When asked by my publisher to write a book on the life in a local oakwood, I accepted happily. I am a great lover of all forests, but the English oak sustains a wider variety of wildlife than any other European tree. Birds and squirrels nest in its canopy; insects devour its leaves; fungi, algae, lichen and mosses invade its bark; birds, insects and mammals feed on its acorns; even the roots are sought out by numerous small organisms. When the tree dies, its rotting carcass continues to support a host of living creatures for many decades.

This oak seedling sprouting from the woodland floor will grow only about 12 inches during its first year. In another 300 years, it will be some 90 feet high and 25 feet in girth—if it survives the onslaught of deer, rabbits, rodents and the myriad plants that compete to occupy its space and steal its light.

SILVER-WASHED FRITILLARY (*Argynnis paphia*)

Generally fast and powerful fliers, fritillaries are found all over the world. The silver-washed fritillary is a large and splendid European species whose hind wings are streaked with delicate hues of green and silver. On hot summer days, it may be seen gliding down from the oak canopy or fluttering daintily across woodland glades in search of thistle or bramble flowers, from which this butterfly has just departed.

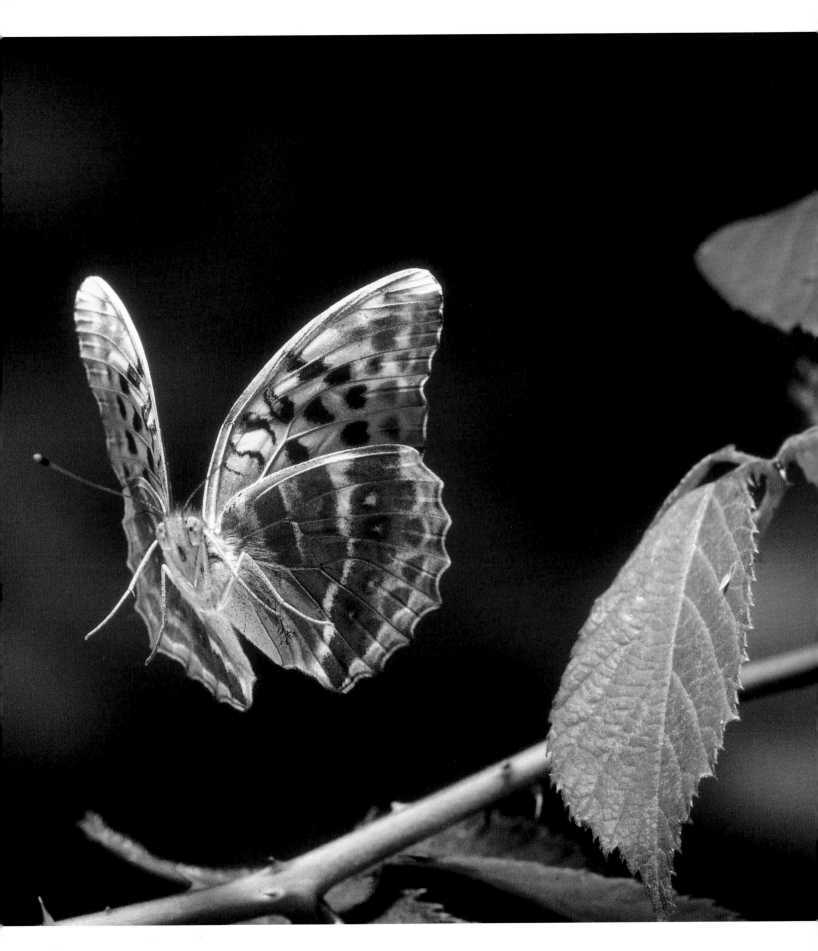

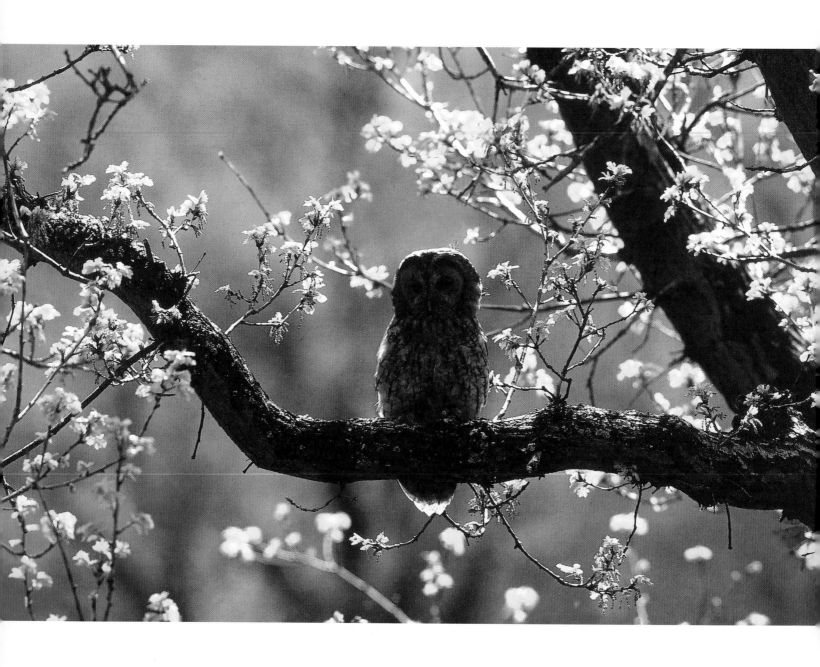

TAWNY OWL (*Strix aluco*)

The tawny, or brown, owl is the most common owl found over much of Europe, and its familiar hooting is the archetype of all owl voices. Not only does it love deciduous forests, but it can also be found in the middle of large towns that boast rodent-rich wooded parks and gardens.

Like most owls, the tawny owl is essentially nocturnal, but this one had been disturbed in its daytime roost by smaller birds and had come out into the spring sun to look for alternative cover.

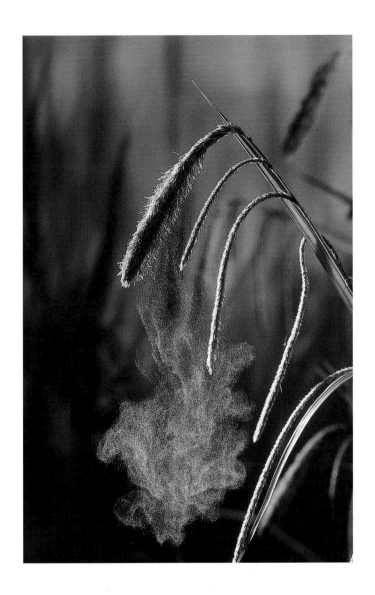

DROOPING SEDGE (*Carex pendula*)

Of the many species of sedge, one of the most distinctive is the drooping, or pendulous, sedge. It has stout, tufted three-angled stems, and its glossy green leaves can grow as tall as five feet. The plant can be found in damp woods on clay soils, especially around woodland ditches and streams. This picture shows the flower spikes shedding pollen.

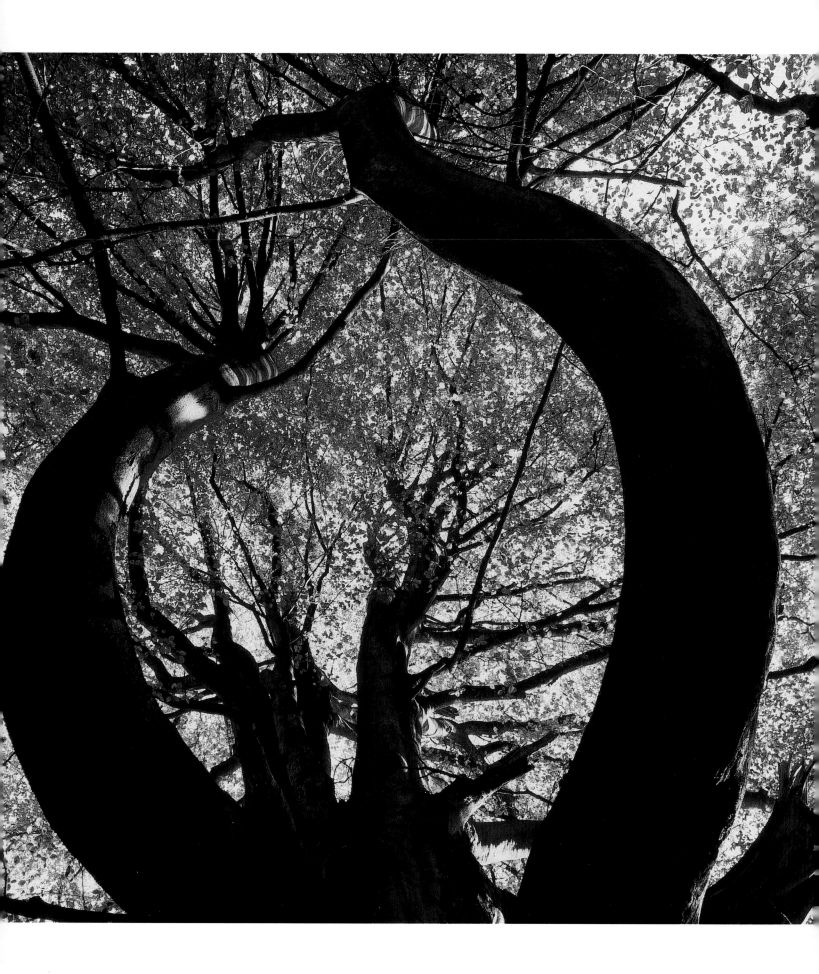

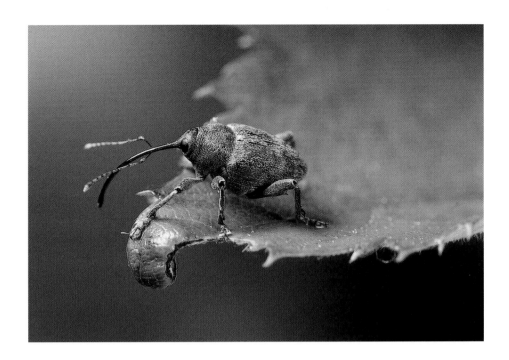

NUT WEEVIL (*Cuculo nucum*)

The diversity of wildlife in a forest depends largely on the variety of trees and herbs within it. An oakwood should contain plenty of open spaces to encourage wildflowers and a healthy understory of shrubs and small trees. Hazel, for instance, provides cover for birds and mammals and food for many insect species, such as this beetle.

As soon as the hazel comes into leaf in spring, the nut weevil emerges from its pupa and starts to feed on the leaves. Later, when the nut sets, the female bores a hole into the shell with her long snout—her mandibles are at the tip—and lays an egg in the kernel. In autumn, when the nut falls, the fully fed larva eats its way out and burrows into the earth to pupate.

EUROPEAN BEECH (*Fagus sylvatica*)

A less common tree in the oakwood is the beech, but what it lacks in numbers, it compensates for in size. This photograph was taken to accentuate the enormous strength of the magnificent beech. Its massive, smooth gray-green trunk, the vast but beautifully contoured limbs, the purity of its fresh spring foliage and its gorgeous autumn colors endow the beech with a majesty that few other trees can match.

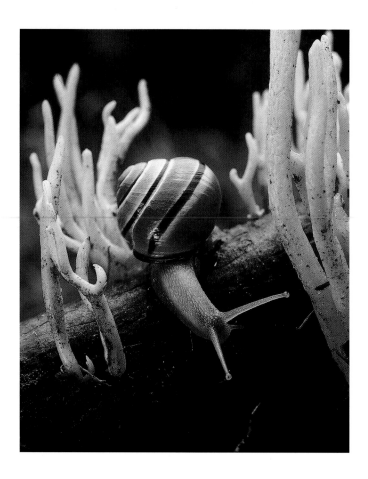

BANDED SNAIL (*Cepaea nemoralis*)

Hardly the subject for high-speed flash and split-second timing, the banded snail, with its five black bands, comes in a wide variety of colors that are determined by the background hues of its habitat. The snail is considered a delicacy by thrushes, and snail shells are frequently found littering the ground around a stone or some other hard object—the thrush's anvil.

Flanking the snail is the golden yellow stagshorn fungus, commonly found growing from buried roots and old stumps around coniferous trees.

PORCELAIN FUNGUS (*Oudemanciella mucida*)

When porcelain fungus is examined close up, it gives the impression of high glaze and fragility. It is usually found living in large clusters high on the trunks of beech trees.

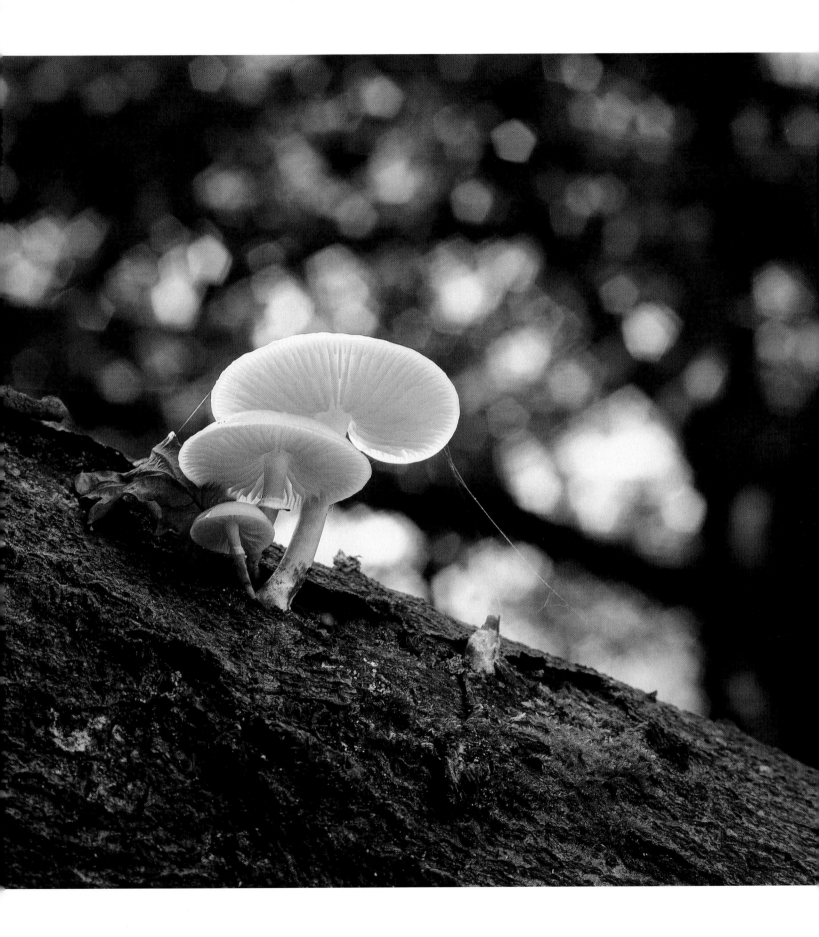

GRAY SQUIRREL (*Sciurus carolinensis*)

Introduced from North America toward the end of the 19th century, the gray squirrel has colonized much of the English countryside. Unfortunately, its spread has coincided with the decline of the far more attractive European red squirrel, *S. vulgaris*, although how much the gray squirrel can be blamed for this is a matter of some debate.

After being abandoned as a baby at the foot of an oak tree, this gray squirrel was hand-reared. She became extremely tame and performed like a star in the studio. In due course, when old enough to fend for herself, she was gradually reintroduced to the wild. There followed a period of several months, however, when she would wander into the house from outside whenever the mood took her.

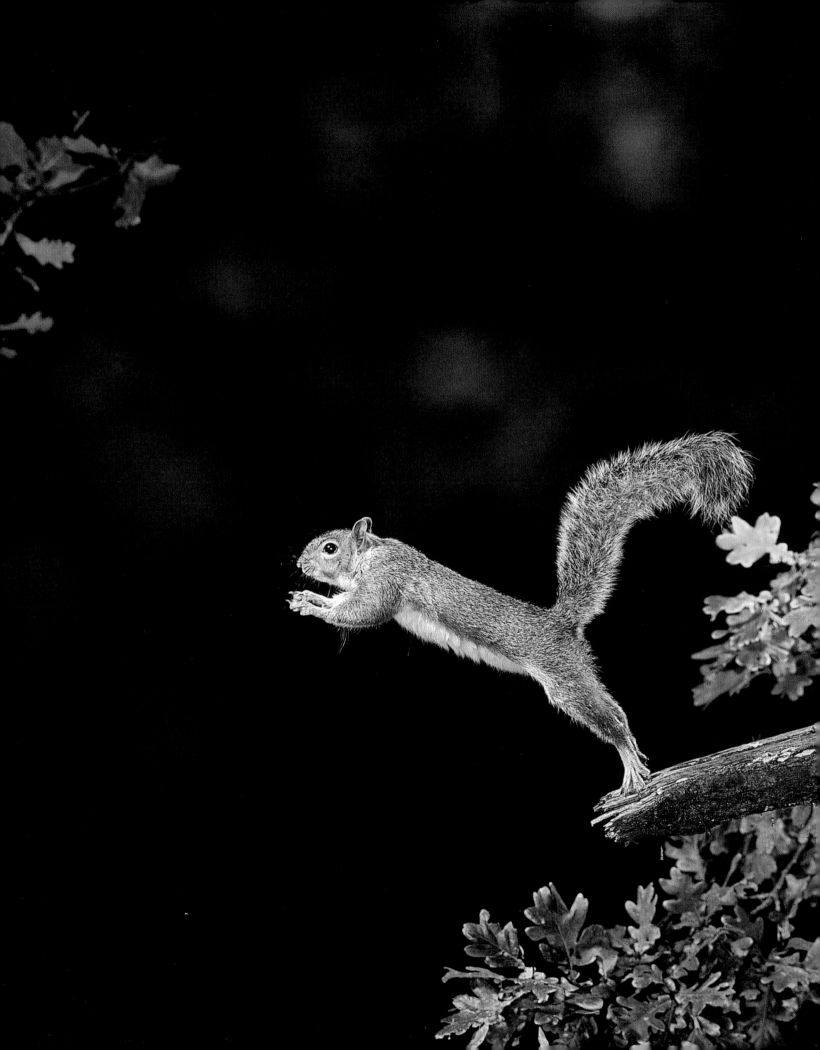

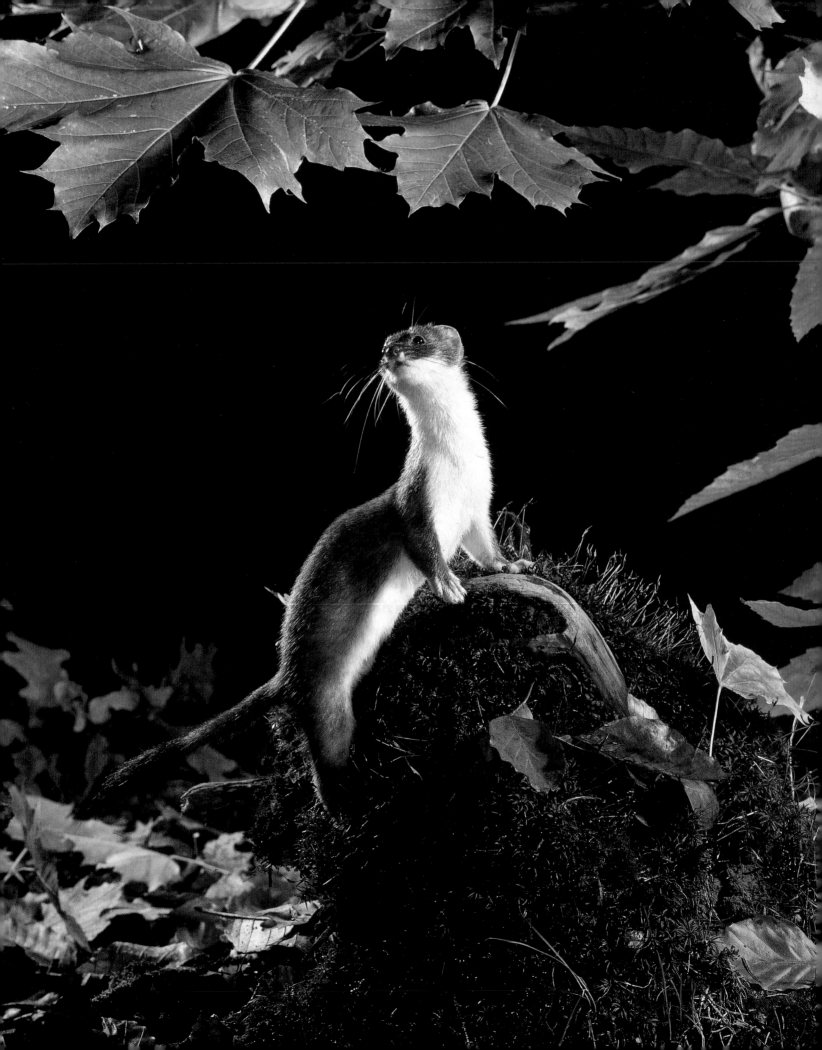

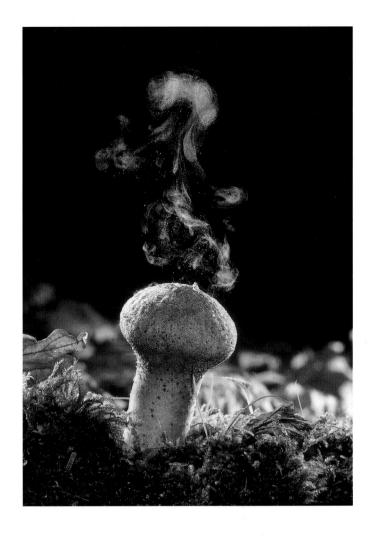

PUFFBALL (*Lycoperdon* sp)

A puff of spores billows upward when a drop of water hits the ruptured cap of a puffball. While there are many species of these fungi in northern Europe, this is the one most often found around rotten stumps and logs in late summer and autumn.

STOAT (*Mustela erminea*)

The stoat has survived despite the gun and trap. Largely nocturnal, although not exclusively so, it hunts for any weaker animal, including rabbits and even fish, which most of the weasel family particularly like. The stoat has a fascinating snakelike way of getting about, moving in a succession of undulating low bounds. Like the fox, it may "hypnotize" rabbits before striking.

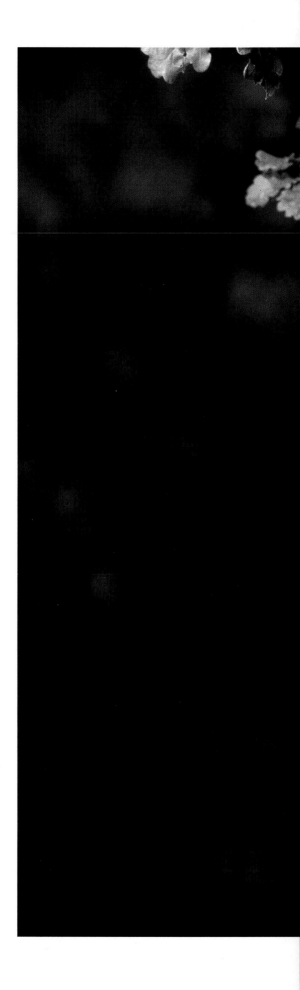

EURASIAN JAY (*Garrulus glandarius*)

A real lover of oakwoods, the jay is a shy, restless and noisy bird. Often all one sees is a glimpse of a prominent white rump as the bird vanishes into the foliage. The jay is long-lived—some have been known to live for 15 years. It tends to have a small territory, rarely flying more than a mile or so from its birthplace.

A relatively high flash speed of about 1/10,000 second is used to arrest the bird's movement as it takes off from the bough of the oak.

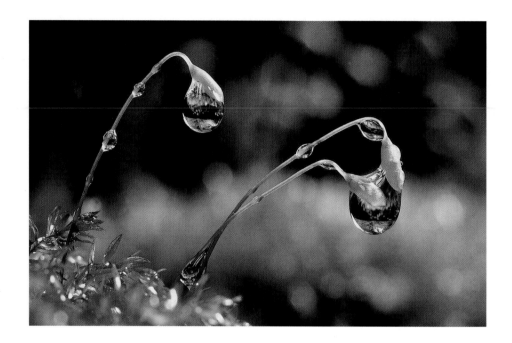

MOSS

Mosses and lichens bring a vibrancy to woodlands and shady
places, coating bare trunks and otherwise denuded banks
with a medley of rich green hues. Moss lacks the leaves,
stems, roots and xylem vessels that conventional plants pos-
sess for conducting food and water around their tissues.
Instead, moss absorbs water over its entire surface, each cell
coming into contact with the growing area to obtain its water
supply. This one sparkles with morning dew.

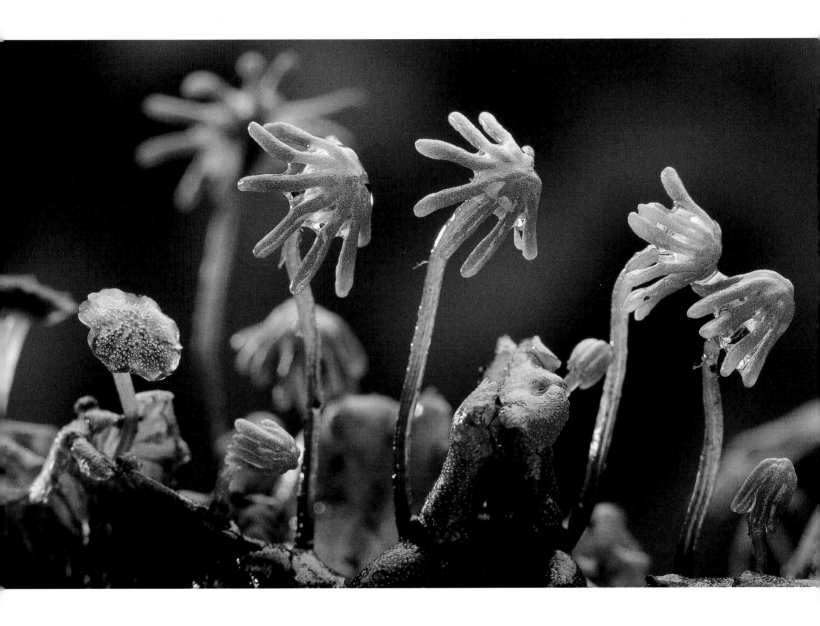

LIVERWORT (*Marchantia polymorpha*)

Liverworts are related to mosses and are made up of fat lobed structures with no conventional roots. Like mosses, liverworts reproduce by means of spores. They are found in damp places, such as the banks of streams. During spring and summer, the plants produce male and female structures, or gemmae. The male parts are disklike, while the female parts resemble miniature palm trees, having about nine spreading fingers. Both structures are visible here.

BROWN LONG-EARED BAT (*Plecotus auritus*)

Bats are in decline due to the destruction of the countryside by modern agricultural practices, a lack of insects and the absence of suitable roosting sites. Hollow trees, for instance, are cut down rather than left to nature, and roof spaces are often sealed to the outside. This is a tragedy, because these harmless but much-maligned creatures are among the most fascinating and friendly of mammals. In England, new laws afford bats extra protection, and a license is now required to enter their known roosting areas or to interfere with them in any way.

Having obtained my license to borrow a bat from the wild, I allowed the animal the freedom of my dining room, where it quickly learned to take mealworms from the hand. Subsequently, the mealworms were replaced with moths, which were eventually coaxed to fly to the right place at the right time.

As well as using echolocation for catching insects, the brown long-eared bat can find its prey passively by listening to the insects rustling amidst foliage. This bat can sometimes be observed at twilight hovering around the branches of trees listening for tasty morsels.

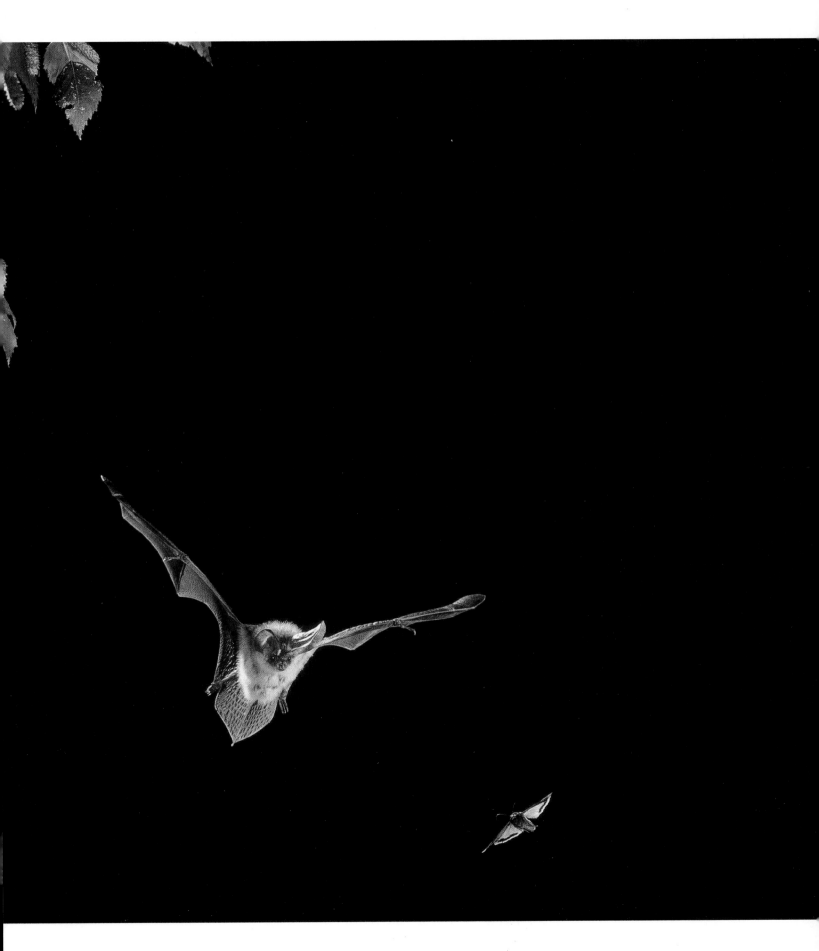

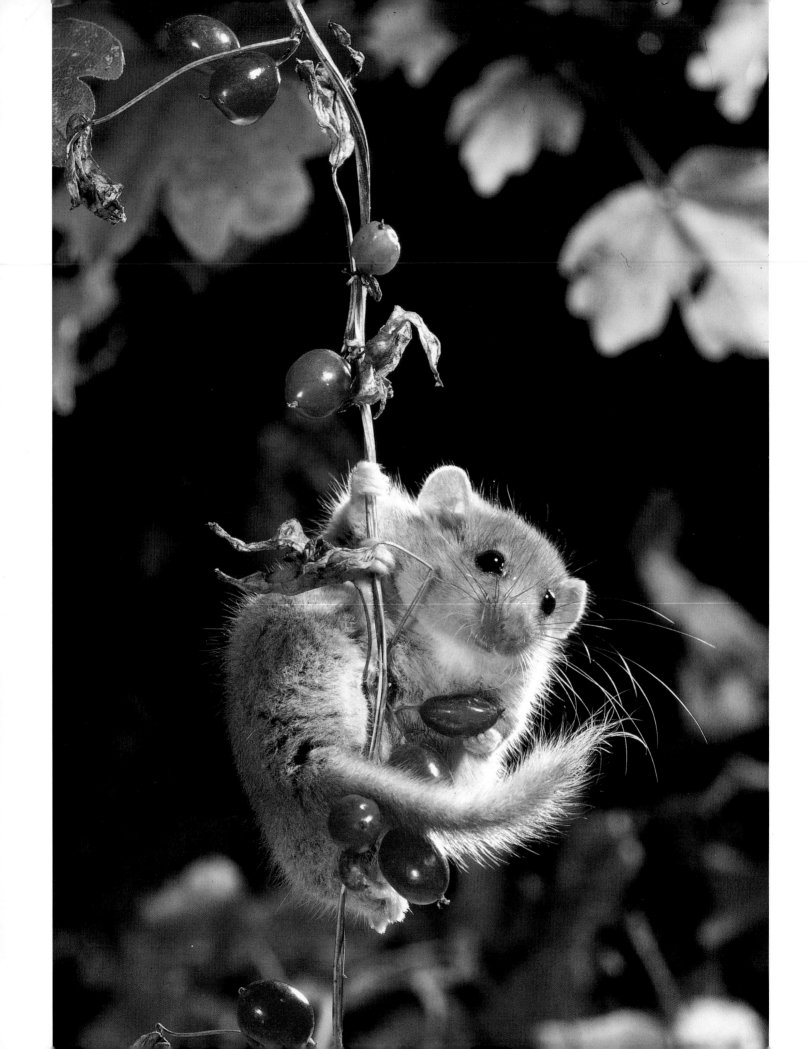

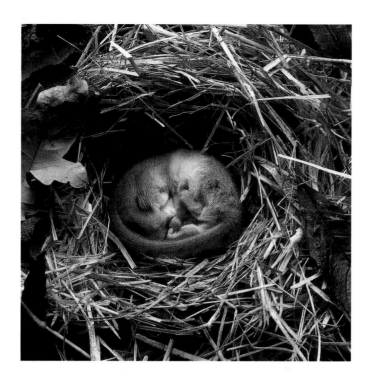

DORMOUSE (*Muscardinus avellanarius*)

The dormouse is not noted for its speed or agility, but while photographing the one pictured here as it meandered around a wild rose, I soon discovered the inaccuracy of this perception. The creature is capable not only of a fair turn of speed in its arboreal habitat, moving among the branches with surprising agility, but also of occasional impressive leaps.

Strictly nocturnal, the dormouse feeds on fruit, nuts, insects and, occasionally, bird eggs, which it hunts in the understory of hazel and other shrubs. In winter, it goes into deep hibernation. Its heart rate and respiration fall, and its body temperature becomes so low that the animal feels cold to the touch and is, as Lewis Carroll noted, difficult to rouse.

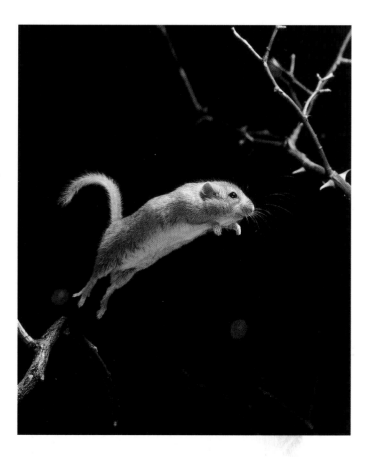

BADGER (*Meles meles*)

The nocturnal badger must be one of the most infrequently seen of mammals. Omnivorous in diet, it feeds on insects, grubs, bulbs, roots, bird eggs and rabbits.

In the past, I have devoted countless hours to badger photography, carrying equipment long distances, staying up late at night and even resorting to unnecessary electronic triggering devices. But apart from this shot of the animal drinking at a stream, all my early efforts were largely unsuccessful. Years later, however, we discovered a thriving badger set within a couple of hundred yards of our front door, and the badgers got so used to the family's comings and goings that we could sit close to them and were privileged to be accepted as part of their local landscape.

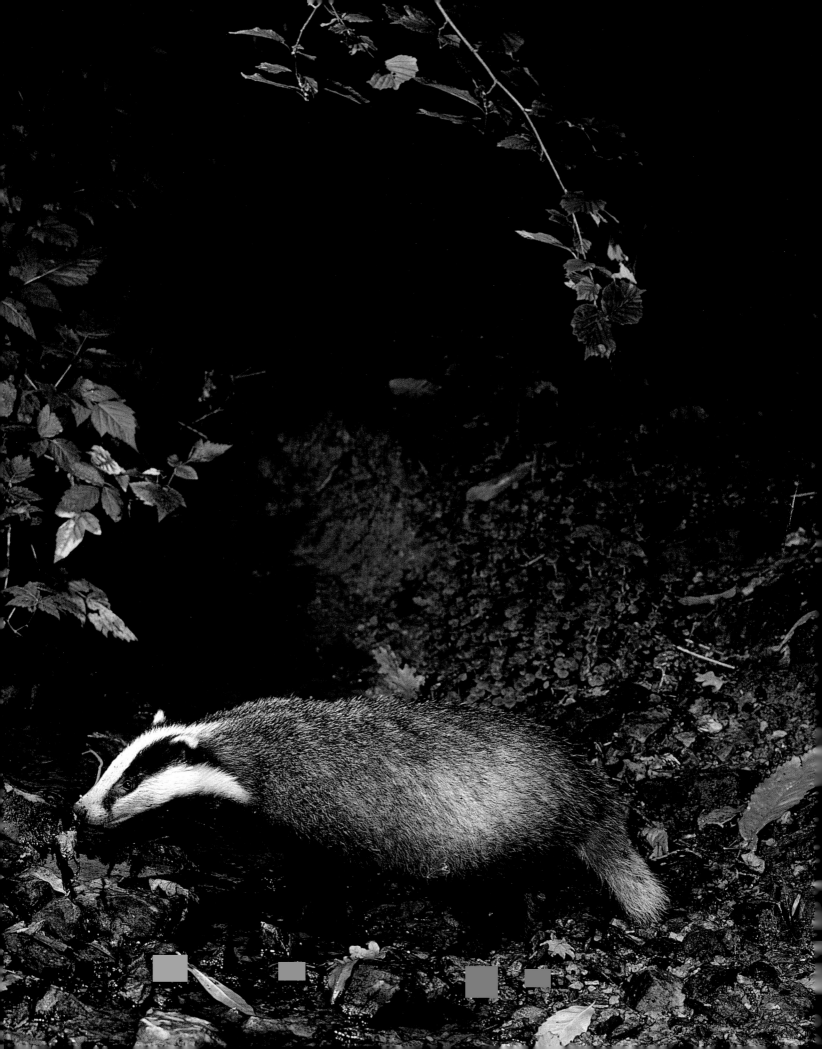

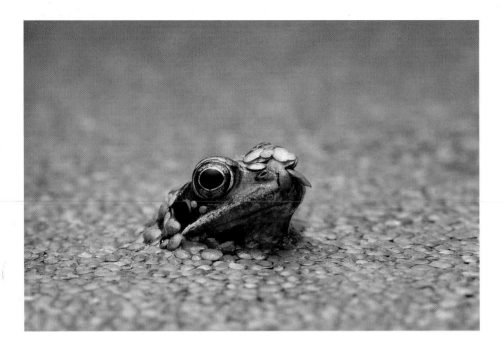

COMMON FROG (*Rana temporaria*)

From beneath the duckweed-covered water, a common frog pokes its nose up for a breath of air. The prominent eyes, with their limpid black pupils and fine golden irises, are perched high up on the frog's forehead. Unlike lizards or snakes, a frog has eyelids. But like birds, it also possesses a nictitating membrane—a protective transparent eyelid. The brown circular patch below and behind the eye is the frog's eardrum.

Like most amphibians throughout the world, frogs are seriously threatened by the effects of global warming and, additionally, by the insidious increase of ultraviolet light through the destruction of the ozone layer.

RIVER KINGFISHER (*Alcedo atthis*)

I have been fortunate enough to have worked with kingfishers on numerous occasions, but the sight of this vivid blue bird flashing downstream low over the water as it utters its shrill call is an experience that never fails to excite.

The bird seen here, carrying a stickleback to feed its hungry fledglings, is approaching its nest hole in the bank of a millstream on the small estate where I spent much of my childhood. Once again, human activities are driving this resplendent bird from many of its favorite habitats, including this stream, where kingfishers have bred for countless generations.

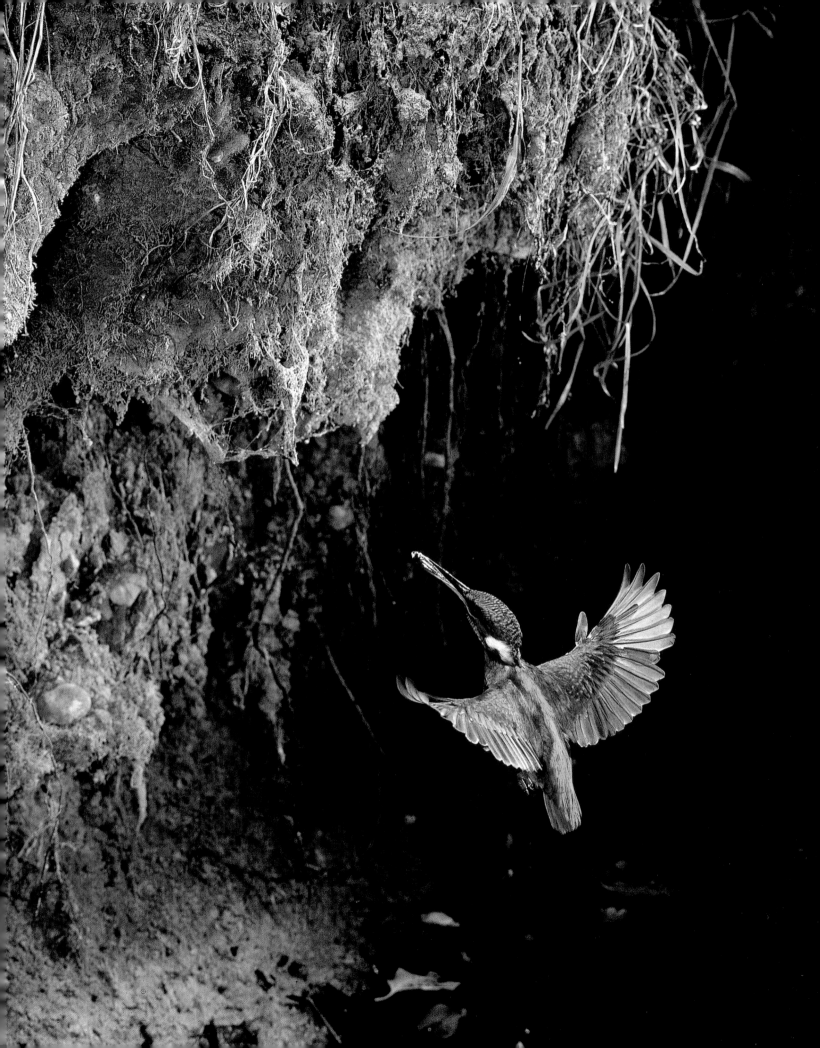

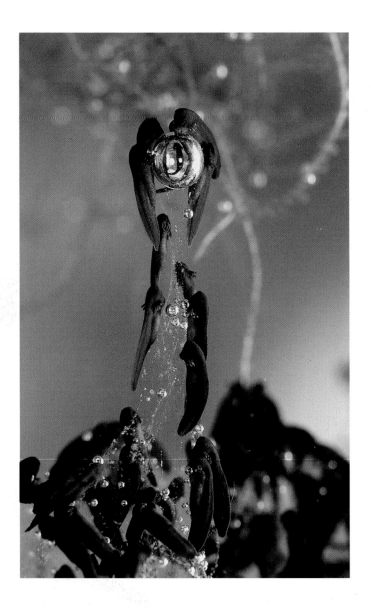

EURASIAN WATER SHREW (*Neomys fodiens*)

In its frantic search for insects in and around water, the enchanting little water shrew seems perpetually on the move. It is equally at home rooting about at the bottom for caddis flies and worms as it is chasing whirligig beetles gyrating on the surface.

When it is underwater, the water shrew takes on a silvery appearance due to the air trapped in its fur. Its broad feet and toes are bordered with stiff hairs, which help with propulsion and control, and its tapering flattened tail has a double fringe of strong hairs on the underside and acts as both rudder and keel.

The water shrew is gregarious in nature and is relatively easy to watch—if you are lucky enough to stumble across a group at the water's edge of a shallow pond or stream.

TADPOLE

Having just hatched from eggs, the tadpoles of the common frog (*Rana temporaria*) cling to the remains of the jelly by means of suckers on the underside of their heads. Eventually, gill plumes will form and mouths appear, enabling the hatchlings to crop soft vegetable matter such as algae. Limbs develop—first the hind, then the front—and the gills are replaced by lungs, which at last allow the froglets to leave the water and live on land.

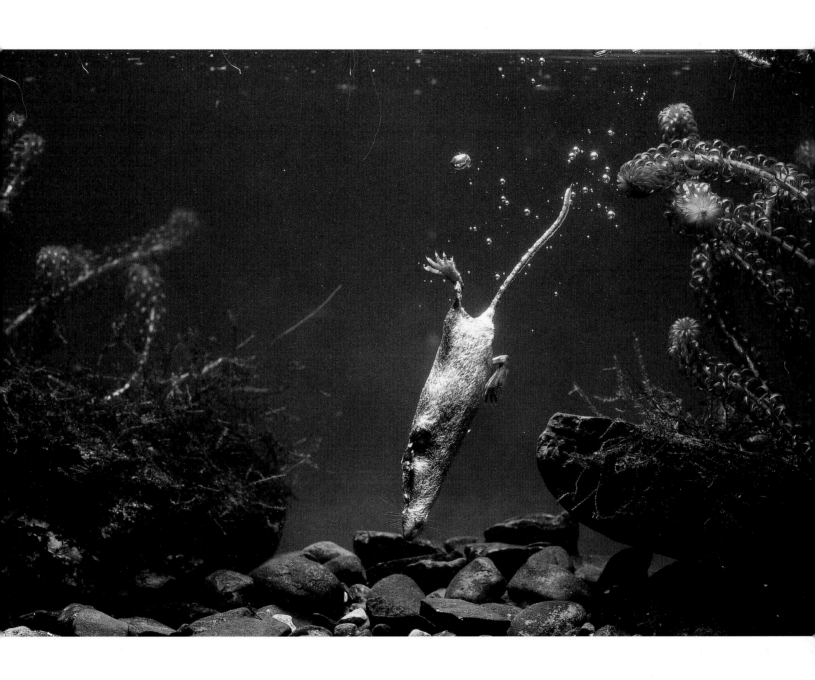

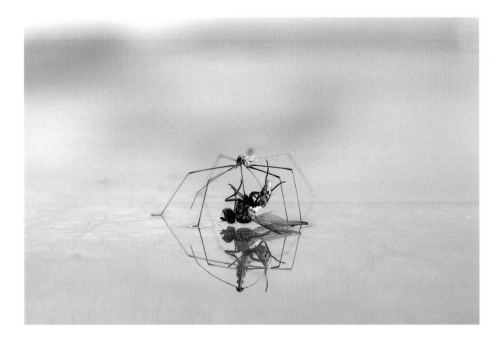

WATER MEASURER (*Hydrometra stagnorum*)

Owing to its very slender body and a tendency to lurk amid the vegetation at the water's edge, the water measurer is not an easy insect to spot. It feeds by walking slowly on the water's surface, detecting insect prey through vibrations. A true bug (Hemiptera), with piercing mouthparts, the water measurer spears its victim with a long, thin proboscis and sucks up its body juices.

LEOPARD FROG (*Rana pipiens*)

This photograph of a leopard frog, taken specially for the front cover of a book on pond life, shows the creature as it plunges into the water after launching itself from the nearby bank.

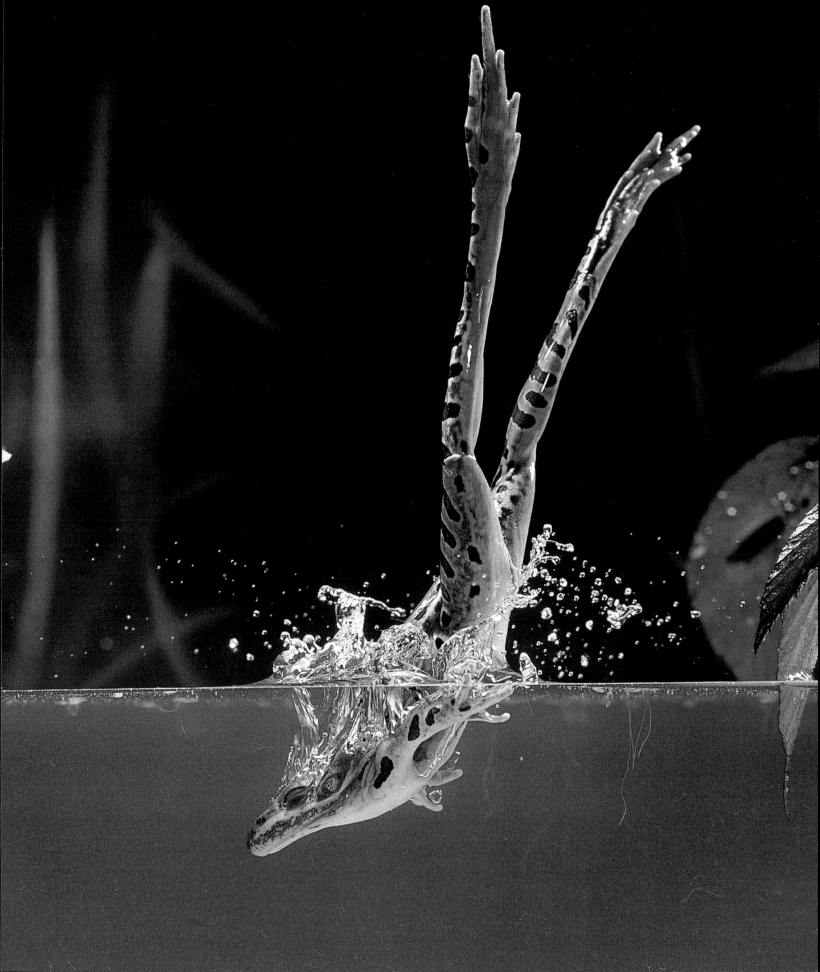

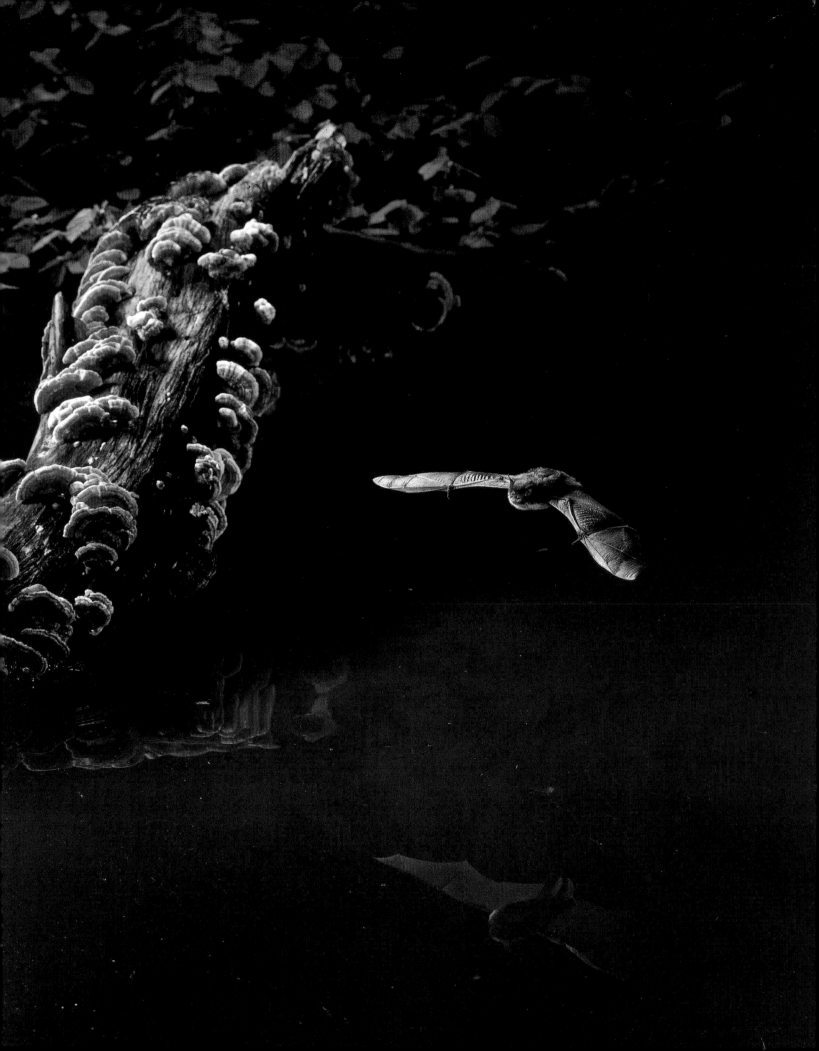

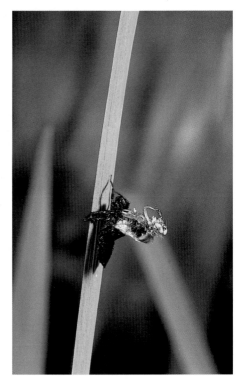 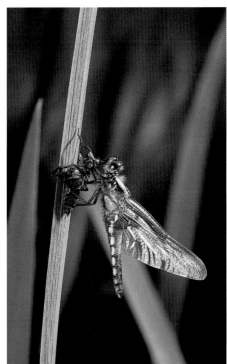 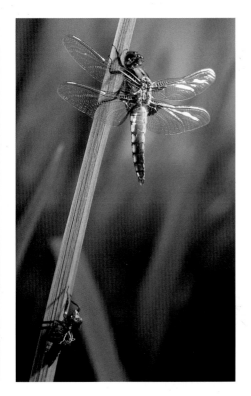

BROAD-BODIED CHASER (*Libellula depressa*)

After spending three years underwater in the mud, a broad-bodied chaser struggles out of its nymphal case and emerges into an aerial world for the first time. Its blood is then pumped into the soft, crumpled wings, which harden and take on a bright gleam. About nine hours later, the insect is airborne.

The dragonfly belongs to the darter family, so called because of its habit of repeatedly darting out on a brief flight from a favorite sunny perch, often to chase off another male, then returning again. The insect is on the wing from May to August and is common in southern England and parts of northern Europe, where it often breeds in small garden pools.

DAUBENTON'S BAT (*Myotis daubentonii*)

This is one of my favorite pictures of one of my best-loved animals, the bat. The set was arranged in our dining room—before the days of a studio—and typifies the natural habitat of this delightful little bat, complete with decaying branch and alder lining the water's edge. The Daubenton's bat is very fond of stretches of water surrounded by woodland.

Its slow, quivering flight as it skims close to the water's surface makes it one of the easier bats to identify on the wing. About an hour before sunset, it awakens and begins hunting for low-flying insects, such as gnats and other water-loving species.

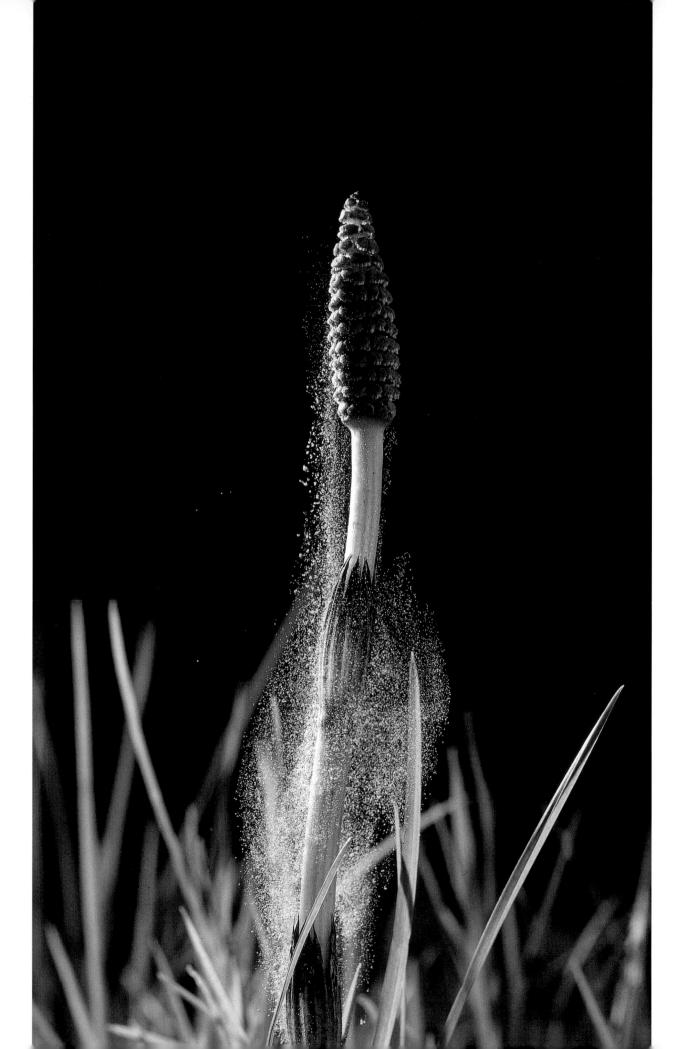

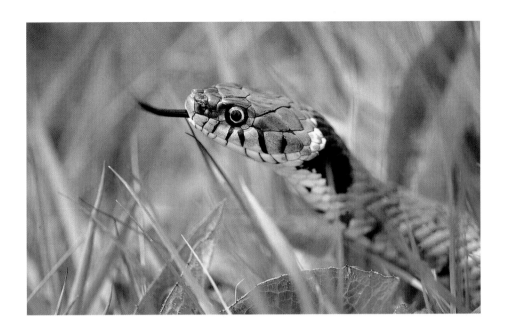

GRASS SNAKE (*Natrix natrix*)

The inappropriately named grass snake is rarely found far from water, since its favorite foods are frogs, newts and fish. Until the beginning of the century, it was called the ringed snake, a more descriptive name because of the yellow collar that appears at the back of its neck.

An excellent swimmer, this reptile can remain underwater for long periods without surfacing. It is also a good climber, occasionally even climbing trees in search of bird eggs. The size of the grass snake varies considerably, with exceptional specimens reaching a length of five to six feet in Britain and up to eight feet in southern Europe.

COMMON HORSETAIL (*Equisetum arvense*)

The horsetail, which belongs to a distinctive family of primitive, leafless, flowerless perennials with tubular jointed stems, produces spores on long egg-shaped terminal cones. Here, a shower of spores can be seen falling from the common horsetail.

Hundreds of millions of years ago, horsetails made up a large group of plants with tree-sized species that grew in enormous forests from which coal eventually formed.

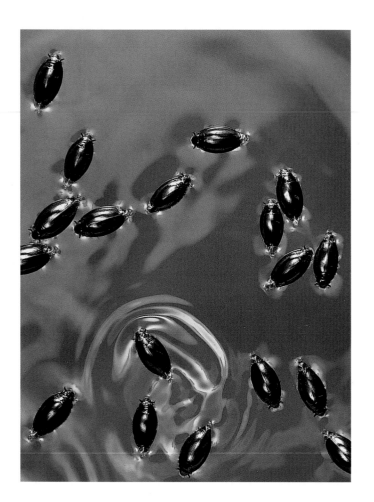

WHIRLIGIG BEETLE (*Gyrinus natator*)

The whirligig beetle spends much of its life charging ebulliently around the surface of slow-moving water, diving under when alarmed. The beetle is small, black and shiny, and the ripples it creates are often what first attracts our attention. It feeds on dead insects and other creatures floating on the surface, and its unusual eyes are divided into two separate parts, enabling the beetle to see above and below the water's surface at the same time.

These beetles swam about with such gusto that only high-speed flash could arrest their movement.

GREY HERON (*Ardea cinerea*)

An early nester, the grey heron sometimes lays its eggs in late winter or early spring. Its young leave the nest about three months later. The heron feeds on fish as well as amphibians, insects, small mammals and fledglings, often standing motionless in slow-moving water, neck outstretched, watching for prey.

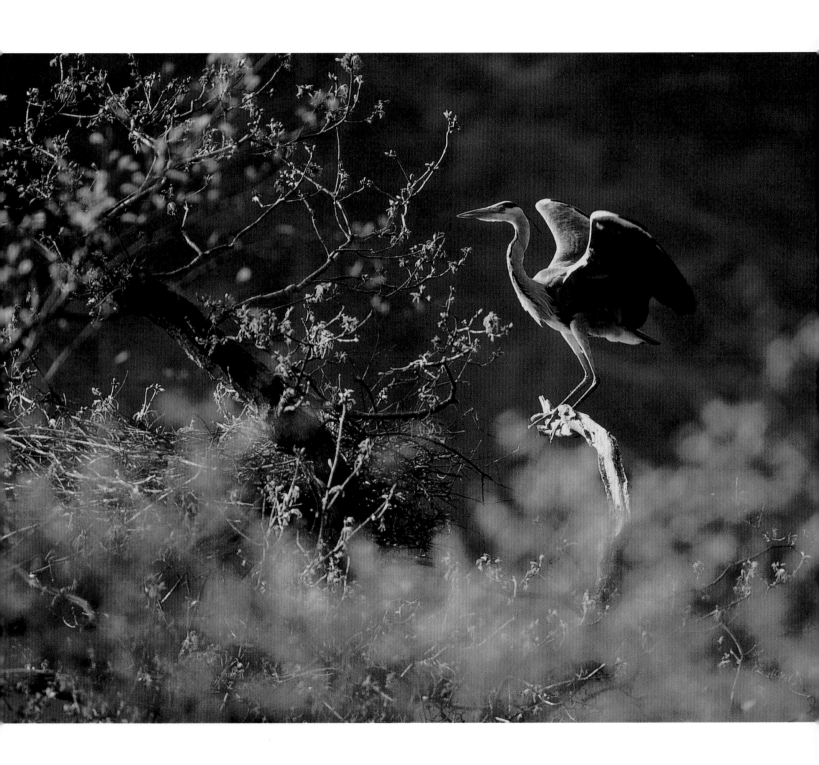

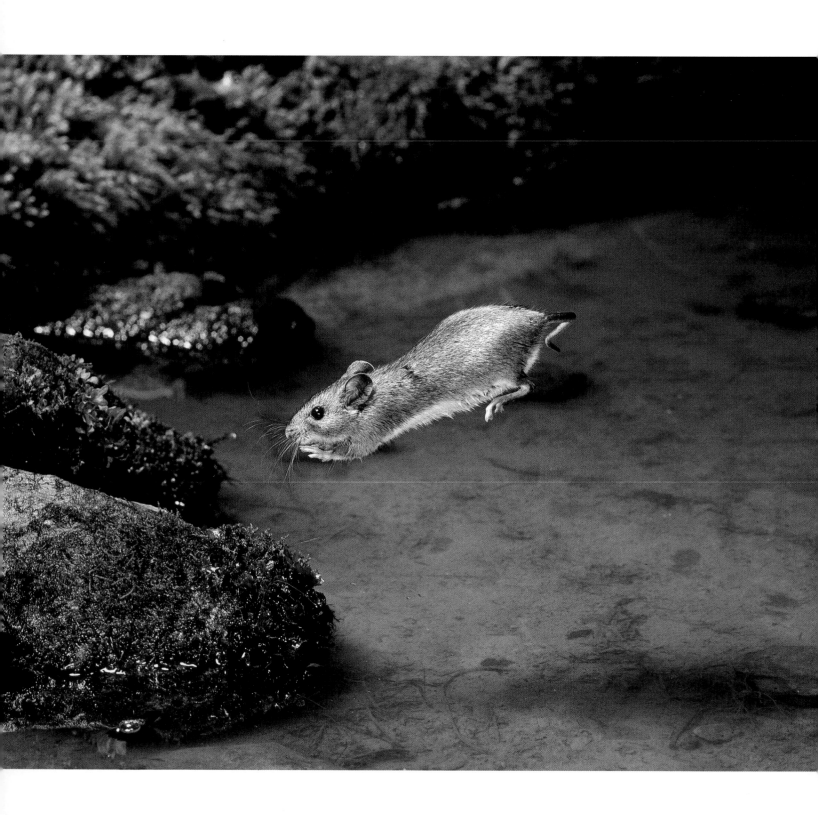

WOOD MOUSE (*Apodemus sylvaticus*)

An extremely supple and agile rodent, the wood mouse moves along in a series of zigzag bounds, with short pauses. It is also capable of jumping and climbing with consummate skill—as it must, for it has many enemies, including owls, weasels, foxes and even hedgehogs. It can be distinguished by its large ears and eyes and a tail that is as long as its body. It typically nests under a tree or in an underground woodland burrow, where it rears its offspring and stores nuts and seeds for the winter.

The wood mouse is a good swimmer as well, and this one is caught bounding from stone to stone as it makes its way across a woodland stream.

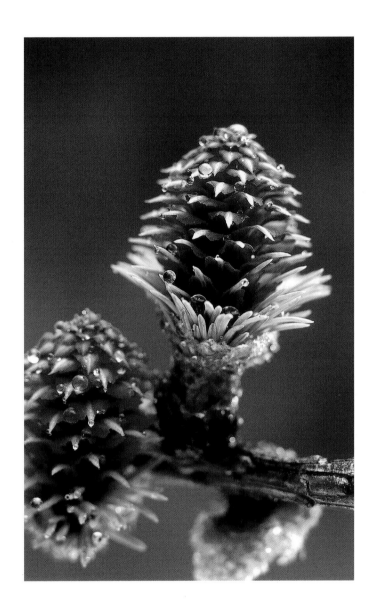

LARCH (*Larix* sp)

During spring, the mists swirl around the water's edge, causing the larch cones to glisten with dew in the early-morning light. There are several species of larch, and all are deciduous conifers, bearing their leaves in bright green whorls.

On Our Doorstep

During the summer of 1976, my wife and I purchased a small farmhouse in the Weald of Sussex within what is described as an "Area of Outstanding Natural Beauty." The property is set amidst gently sloping hills, deciduous woods and small fields and has far-reaching views of the South Downs. Nearly 15 years later, I produced a book about the wildlife that lived in or visited our garden—a half-acre plot which was just part of a field when we first arrived. A selection of the photographs taken for that book is presented here.

In due course, the farm surrounding our house came up for sale, and for reasons that were not entirely of our making, we found ourselves the proud owners of some 50 additional acres.

This extra land was managed in a gentle way to provide a greater variety of habitats. As well as planting hedges and trees, we banned the use of artificial fertilizers and insecticides, and spot-spraying of "obnoxious" weeds took place only when absolutely necessary. Some of the wildlife that now thrives here is included toward the end of this chapter.

In contrast to the photographs featured in much of this collection—the majority of which are of indigenous animals and were largely taken outdoors—the few that appear in the final pages are of aliens, animals which typically inhabit rather more exotic places than Sussex, England. But for a variety of practical reasons, these creatures have been photographed in the "natural" inside setting of my studio. Notes about some of the difficulties encountered during these photography sessions, together with aspects of the animals' behavior that may be difficult to observe in the wild, are included in the captions.

AERIAL VIEW OF THE WEALD OF SUSSEX

The boundaries of our "extended garden" are clearly visible in this aerial photograph, which I took from a hot-air balloon that obligingly floated down the valley one calm evening in early autumn. The property limits are marked by the wooded margins seen at the bottom, left and top left of the photograph, while the house, garden and farm buildings are just visible toward the top right. We managed the extra land so that it provided a greater variety of wildlife habitats.

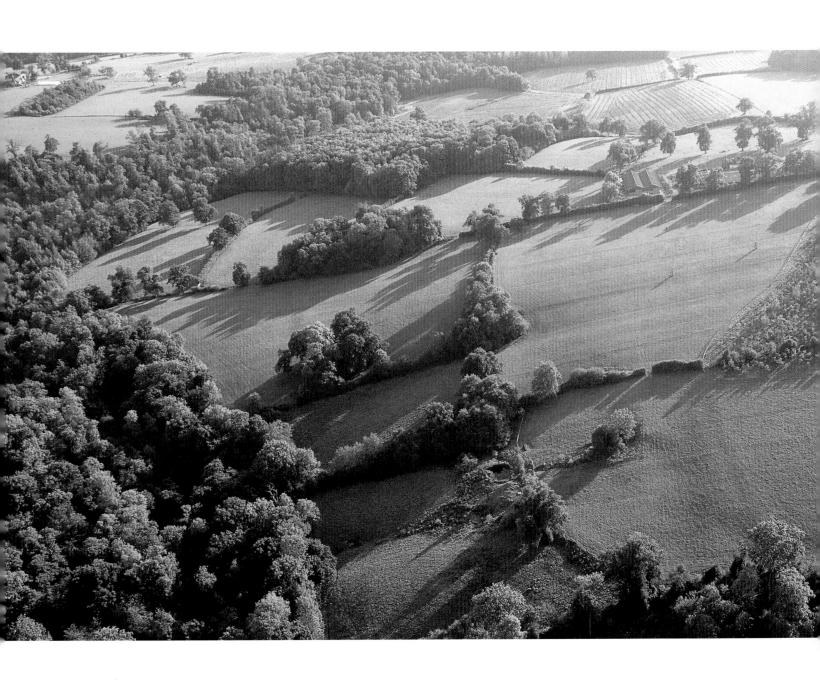

EUROPEAN HEDGEHOG (*Erinaceus europaeus*)

The hedgehog has very poor eyesight and so uses its acute sense of smell to locate food, which consists of almost any invertebrate it finds, although larger animals, such as mice, frogs and even snakes, are occasionally tackled. An excellent swimmer, the hedgehog is also able to climb trees and walls with relative ease.

At the slightest threat, the hedgehog rolls up into a spiny ball. As it is so well protected, the hedgehog has few natural enemies, although badgers and foxes sometimes succeed in unrolling the ball of spines. This creature's behavior of rolling into a ball has stood it in good stead for the past 20 million years or so but is not the most effective defense for avoiding the automobile.

In England, we most often see the hedgehog on the road, but it is more likely to be heard in a garden setting, where its presence is betrayed by a large repertoire of grunts, squeaks and screams. The recent decline in hedgehog numbers can also be attributed to the use of slug pellets and other poisons in the garden, which are consumed by the hedgehog.

LADYBIRD (*Coccinella 7-punctata*)

Like the hover fly, the ladybird, or ladybug, ruthlessly preys on aphids and scale insects and so should be given every protection possible. Its bright and contrasting colors warn predators that it is foul-tasting. Typically, the larva is a pale-spotted bluish gray grub that, like the adult, wanders about foliage in search of prey.

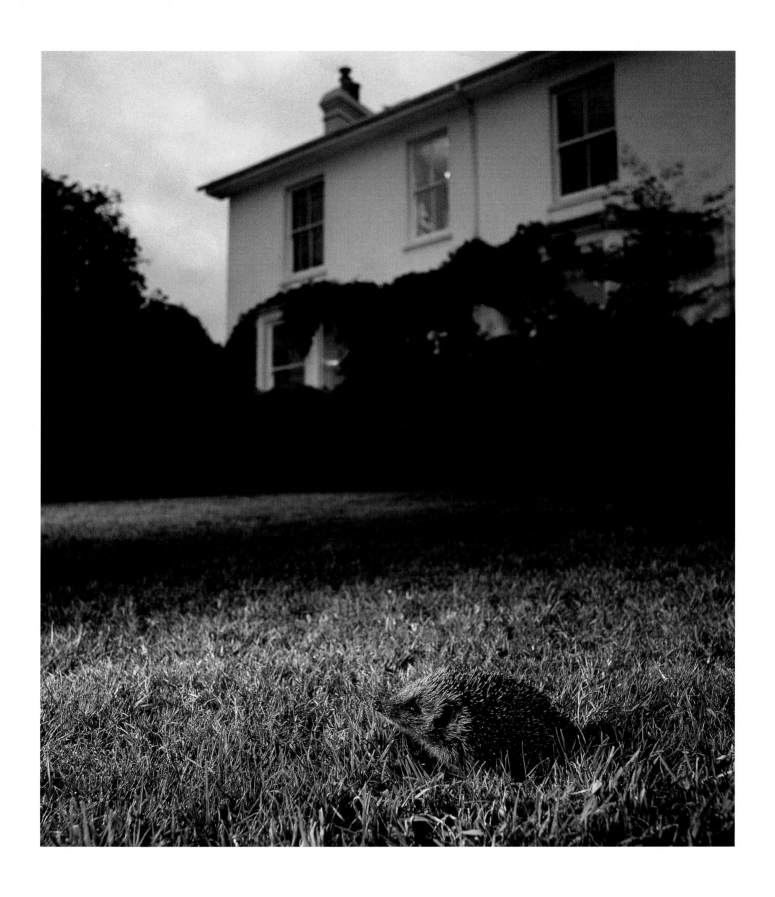

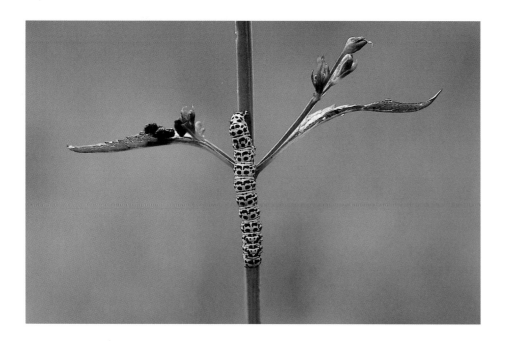

LARVA OF MULLEIN MOTH (*Cucullia verbasci*)

This mullein moth larva is feeding on water figwort, but mullein and buddleia also serve as food plants. The eye-catching caterpillar is a striking contrast to the superficially dull brown moth of adulthood. Nevertheless, the moth's form—its pointed, serrated wings are not unlike the edges of a postage stamp—and color camouflage the insect during the day as it rests on the trunk of a tree.

BLUE TIT (*Parus caeruleus*)

Specially photographed for the front cover of the garden wildlife book, this blue tit was persuaded to pose on a winter-flowering viburnum when the branch below was baited with peanuts. The bird, together with its many companions, soon learned to ignore my restless activities as I hovered around making adjustments.

Although the blue tit is really a woodland bird, it can be encouraged to visit the garden regularly by putting out suitable food in the winter months and mounting nest boxes during the spring and summer.

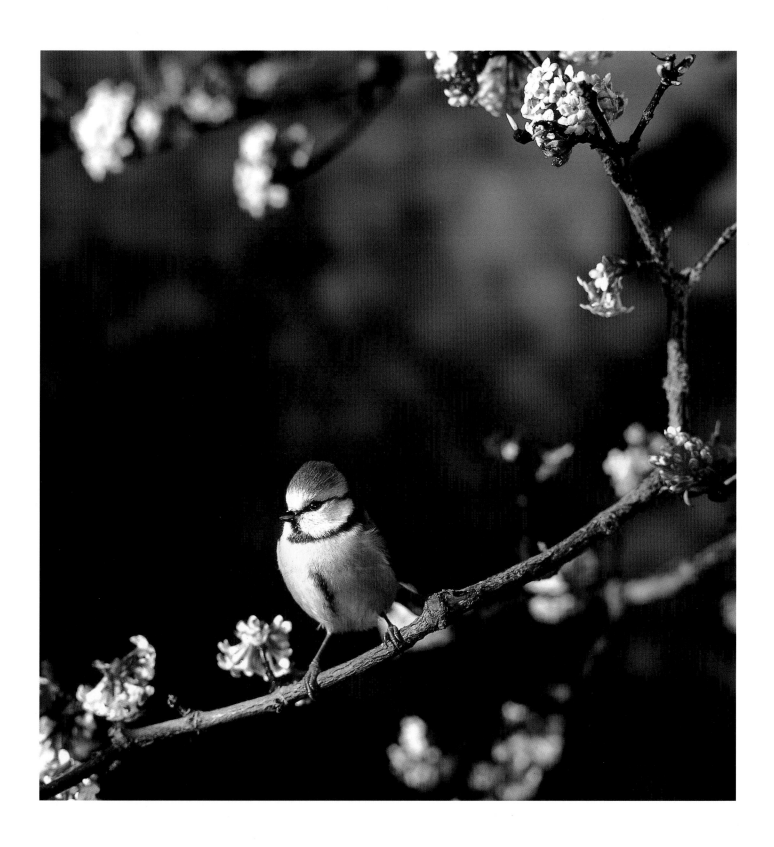

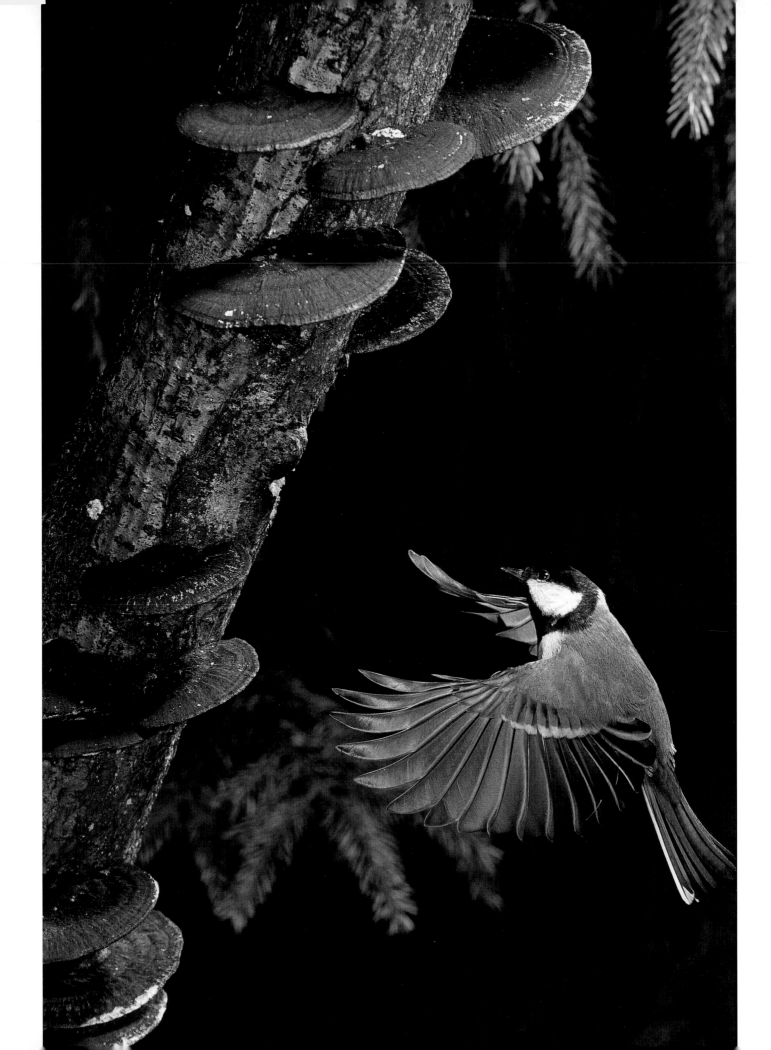

KATSURA TREE
(*Cercidiphyllum japonicum*)

With its multistemmed trunk and glorious autumn coloring, the cercidiphyllum, or katsura, is one of the loveliest of trees. Here, its leaves are edged with water droplets that catch the early-morning sun. The tree originates in the Far East and is one of the first trees to be planted in the garden.

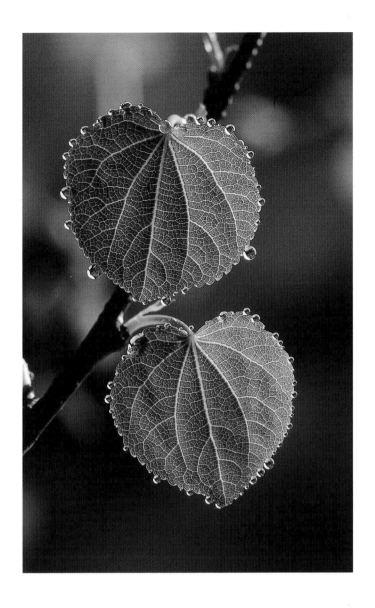

GREAT TIT (*Parus major*)

Essentially woodland creatures, tits are among the most familiar birds in England, where many species are readily attracted to gardens by nest boxes and feeding stations. Here, a great tit alights on the bole of a fungus-ridden tree.

Like other members of its family, the great tit nests in holes, where its eggs and young are protected from many of its enemies—although not from weasels and mice, which are climbers and can enter the nest holes with ease. When the fledglings leave the nest, they must then contend with other predators, such as sparrowhawks.

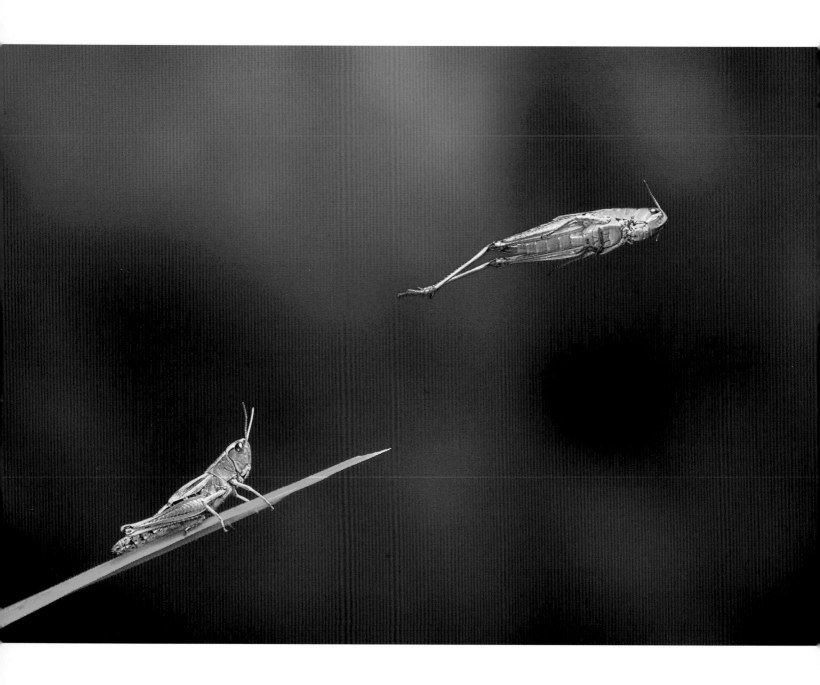

MEADOW FOXTAIL (*Alopecurus pratensis*)

Among the most attractive qualities of flowering meadows is the restrained beauty of grasses, yet these ecologically rich habitats have, in the twinkling of a farmer's eye, vanished from the English countryside. Some hay meadows remain, but most grassland is now cut for silage before the grasses come into full flower, destroying the invertebrate life that depends on it and precipitating an equally destructive ecological chain reaction.

Here, a gust of wind wafts pollen from the flowers of meadow foxtail over the surrounding landscape.

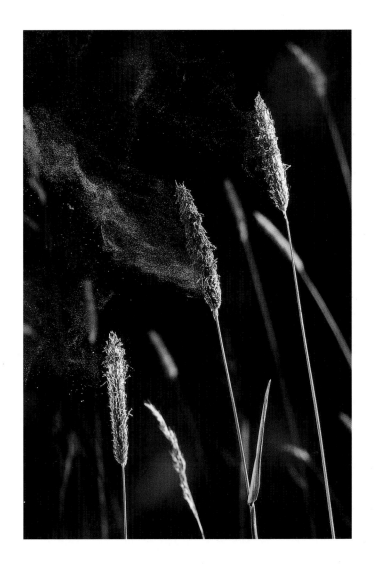

SHORT-HORNED GRASSHOPPER (*Locusta* sp)

It is difficult to freeze the movement of a grasshopper completely during the early stages of takeoff unless a very high-speed flash is used (at least 1/50,000 second) or the magnification of the image is kept fairly low, as is the case here.

Short-horned grasshoppers, or locusts, such as the one pictured here, are generally foliage eaters. Bush crickets and katydids, on the other hand, which possess long filamentous antennae, tend to be omnivorous or carnivorous in their feeding habits.

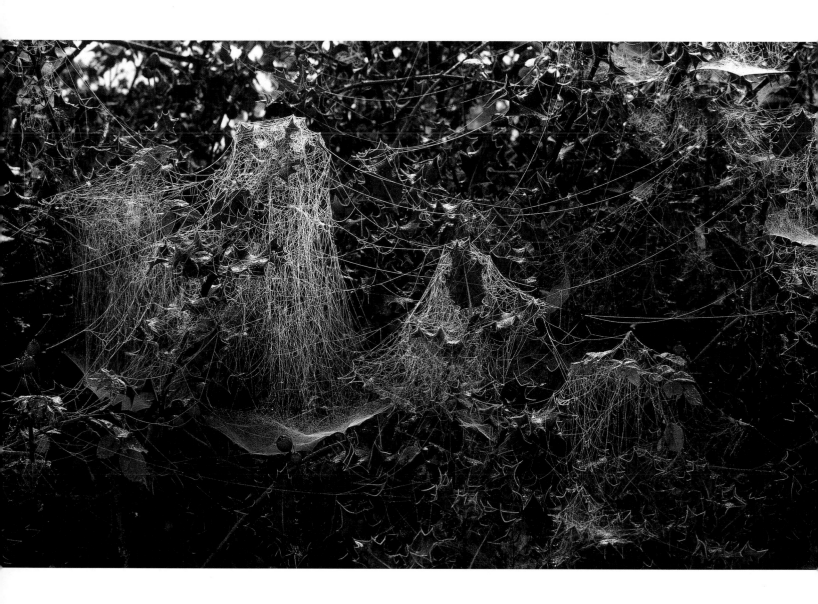

AUTUMN COBWEBS

The dew-covered webs glistening on hedges and lawns in autumn are made by money spiders (Linyphiidae), a group of arachnids that contains several thousand diminutive species, most of which are only one-eighth of an inch long. The spiders are stirred into restless activity in the fall, and they cloak the countryside with crisscrossing filaments that shimmer in the early-morning light. With the help of their silken strands, money spiders are able to travel for thousands of miles, floating on rising air currents as aerial plankton.

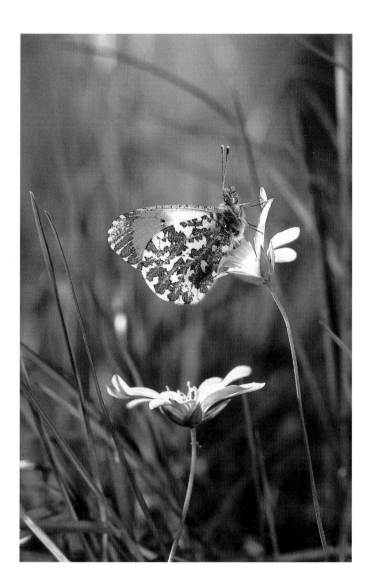

ORANGE-TIP BUTTERFLY (*Anthocharis cardamines*)

Often glimpsed flying jauntily down a country lane in early spring, the orange-tip butterfly also frequents gardens, especially those with nectar-rich wildflowers. The female likes to lay her eggs on lady's-smock and garlic mustard. A member of the white family (Pieridae), the orange-tip has two broods: The first appears on the wing in early spring, the second in late summer.

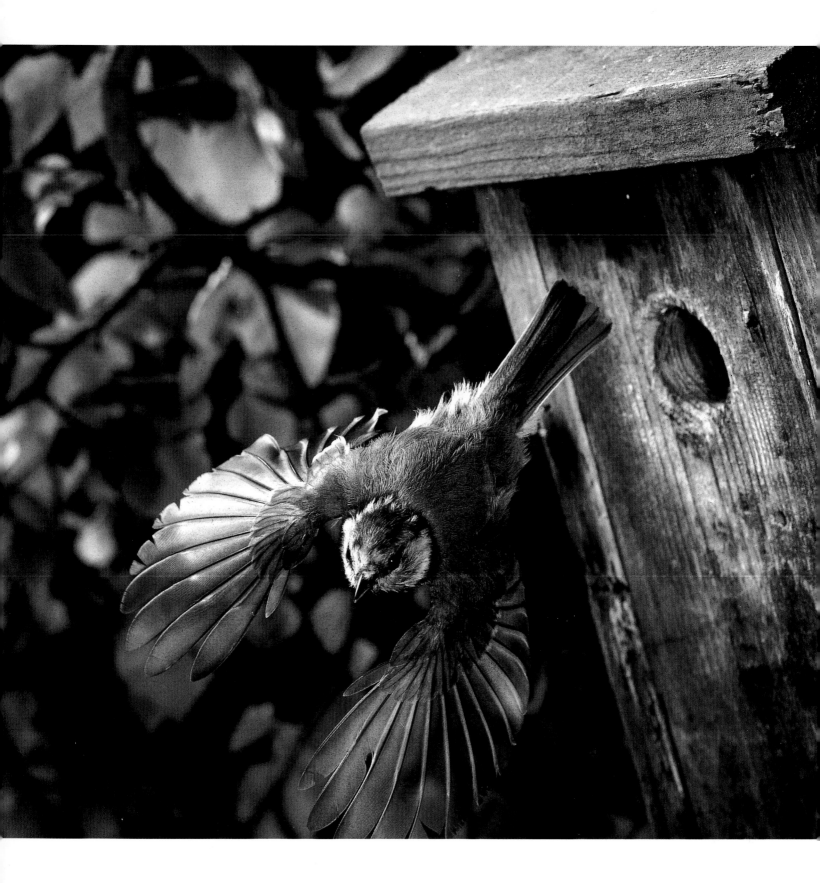

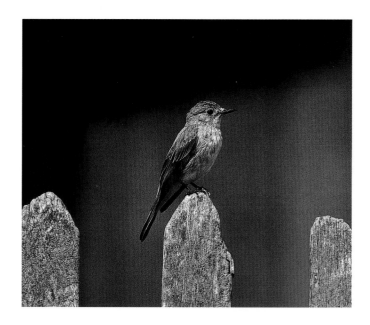

SPOTTED FLYCATCHER (*Muscicapa striata*)

I always feel privileged when a pair of spotted flycatchers nests in the garden. In England and northern Europe, the flycatcher is one of the last summer migrants to appear, arriving in mid-May and returning to Africa between July and October.

The spotted flycatcher is essentially a woodland bird, but large gardens with mature trees and a good supply of insects are also suitable habitats. What makes this little brown bird so engaging is its manner of catching prey. It flutters out from its perch on a dead branch or a fencepost, twisting and turning in the air in pursuit of an insect, before returning to the same perch or one nearby.

BLUE TIT (*Parus caeruleus*)

Darting out of its nest box with explosive speed, a blue tit sets off once more in search of caterpillars to satisfy the insatiable appetites of its numerous fledglings—one brood requires from 500 to 1,000 caterpillars each day. The size of the family depends on the availability of food: A hen nesting near woodlands may lay up to 14 eggs, but in gardens, where suitable food is likely to be scarcer, smaller clutches are more typical.

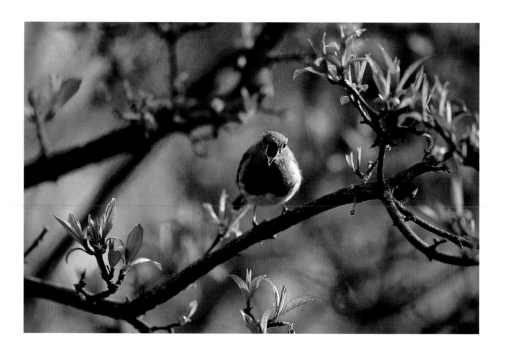

EUROPEAN ROBIN (*Erithacus rubecula*)

England's national bird, the much-loved robin (a different genus and species from the American robin) is so appreciated that those living in parks and gardens often become very tame. Robins in Continental Europe, however, tend to be more secretive and difficult to observe, but they may be heard singing during most months of the year. The cock bird pictured above is clearly putting his heart and soul into proclaiming his spring territory.

At the time this photograph was taken, another cock bird was staking its overlapping territory a mere 20 yards away. Every so often, the birds would meet and aggressively pursue each other among the branches of the garden shrubs.

Robins nest almost anywhere, including on the banks of streams and rivers, on the ground, in hedges, shrubs, old machinery and tin cans and, in this case, on a shelf in a garden shed. The flash lighting was set up to emulate the soft natural light coming in from the open door. As well as attracting robins, this vine- and peach-festooned shed provides shelter for wrens, mice, toads and a multitude of insects and spiders.

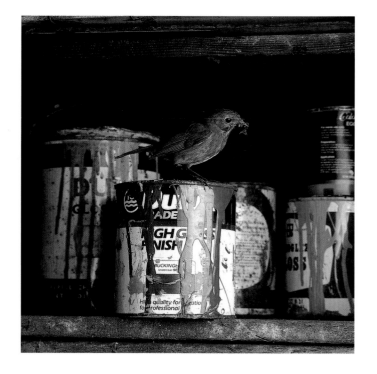

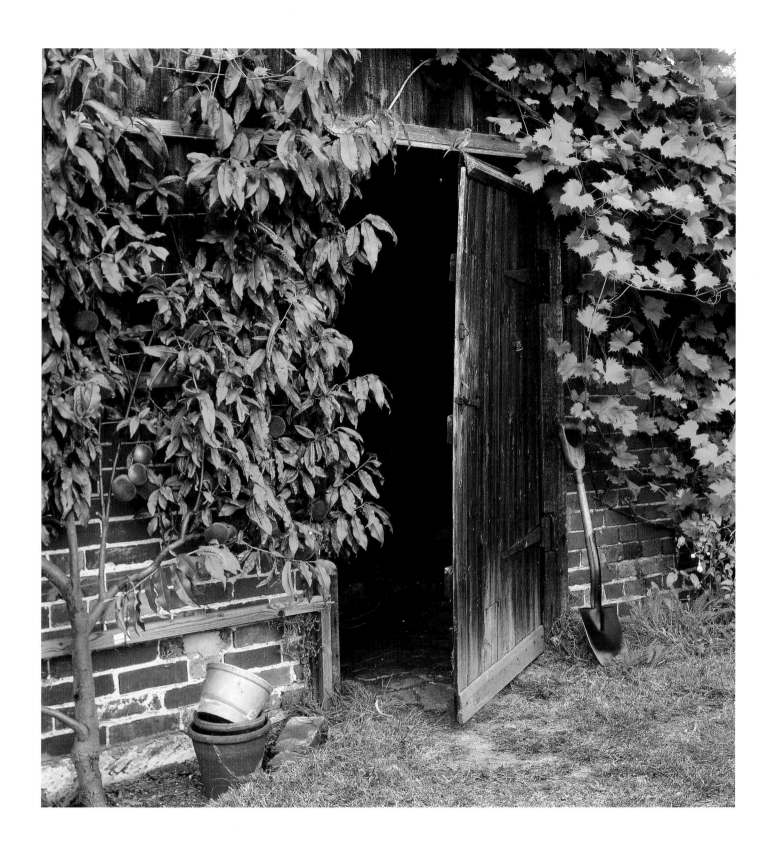

HONEYBEE (*Apis mellifera*)

It is surprising how creatures with rudimentary nervous systems, like insects, seem to vary in "character" from one individual to another. For instance, once I've prepared the set, I might collect three honeybees from the garden. Upon their release in the flight tunnel, one of the honeybees might fly off at a crazy tangent, completely ignoring the colorful nectar-laden flower and bright sunlight at the end of the tunnel; another might flop about and be reluctant to fly at all; and the third, if I'm lucky, might take off and make a beeline for the planned exit, breaking the light beam at exactly the right place time and time again.

A picture such as this can consume several rolls of film and require a couple of dozen specimens. As bees rapidly run out of energy without food, each one has a limited useful "flight-tunnel life" of between 10 and 20 minutes. After that, the bee is returned to a garden flower for a feed before it flies off to continue with its life.

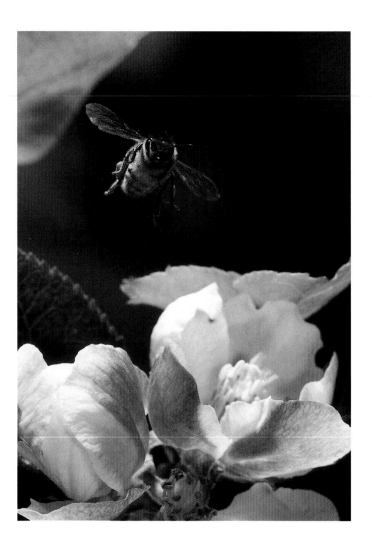

COMMON TOAD (*Bufo bufo*)

Each night, the common toad ventures out from its hiding place to hunt for insects, slugs, worms and, indeed, any creature it can swallow. Considering how lethargically the toad proceeds on foot, it comes as a surprise to see it catch prey. The toad slowly approaches to within striking distance. Its bulbous tongue shoots out of a gaping mouth, enveloping its victim (in this case, a worm), then withdraws in a flash. If the prey is large, the toad may cram the remainder of the meal into its mouth using its front feet. As the toad has an insatiable appetite, it has no difficulty enjoying a continual feast.

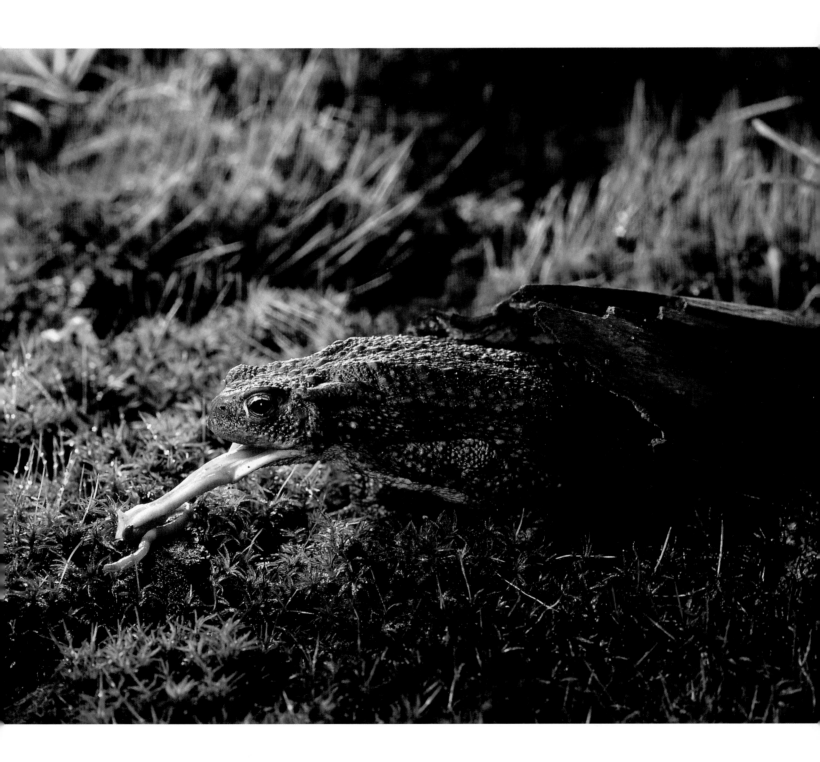

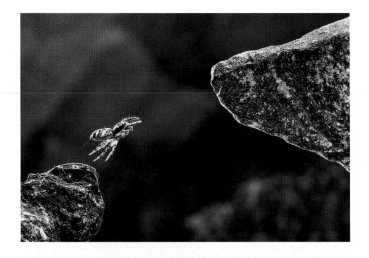

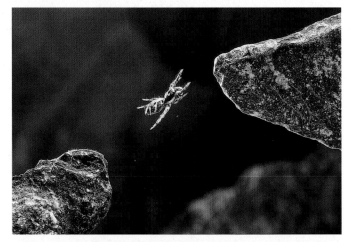

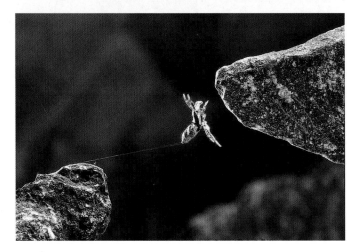

ZEBRA SPIDER (*Salticus scenicus*)

I have always had an affection for the jumping spider—such as this zebra—a tiny creature with a nimble body that seems to be perpetually on the move in search of small insects. Rather than making a web to ensnare its prey, the spider walks in a series of jerks. When it spots an insect, using its highly sensitive battery of eyes, it stalks it as stealthily as would a cat, leaping onto its victim's back. The sudden jump is powered by the hydraulic action of the spider's legs (some species can jump up to 20 times their body length).

Although I have also used multiflash to record jumping spiders, the technique is limited to black or very dark backgrounds, which impose certain photographic constraints by excluding natural-looking settings. Here, the action of a zebra spider is shown in a sequence of separate pictures.

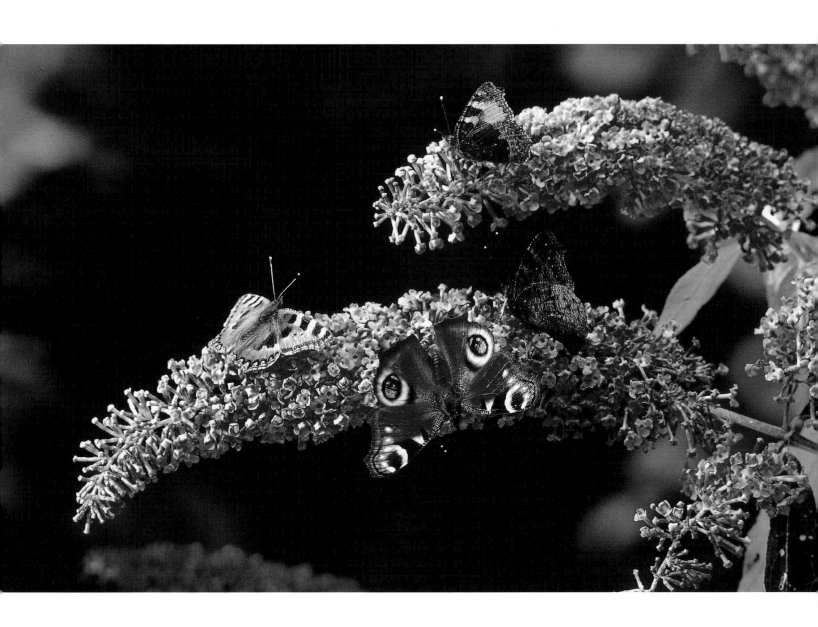

BUTTERFLIES AT BUDDLEIA

One sure way to attract butterflies to your garden is to plant a butterfly bush (*Buddleia* spp). Here, two peacocks (*Vanessa io*) and two small tortoiseshells (*Aglais urticae*) feast on the copious quantities of nectar the shrub produces. The mouth-parts of insects vary, so different species can collect nectar from different types of flowers. Butterflies and most moths have a long proboscis, enabling them to reach to the bottom of the flower's narrow corolla tube for nectar.

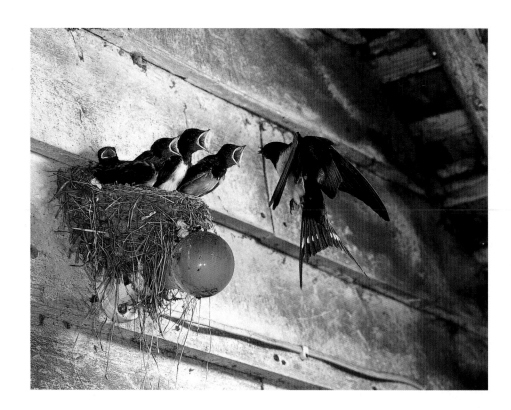

BARN SWALLOW (*Hirundo rustica*)

One to two thousand years ago, before the countryside became cluttered with houses, swallows nested in caves and hollow trees. Nowadays, they prefer to raise their offspring inside barns and other outbuildings, an adaptation that allows us to rejoice in their aerial virtuosity and vocal chattering at close quarters. This mud-cup nest was constructed on a light fixture in an old stable.

One of the parents was photographed rushing out of the stable entrance. The light-beam receptor is hidden in the straw on the floor, and to emulate natural lighting, the high-speed flash was carefully positioned, then balanced to match the midafternoon sunlight. Added excitement came in the form of an enormous Hereford bull that was sharing the same enclosure as my camera—every so often, I had to push the overly friendly animal away with my bare hands.

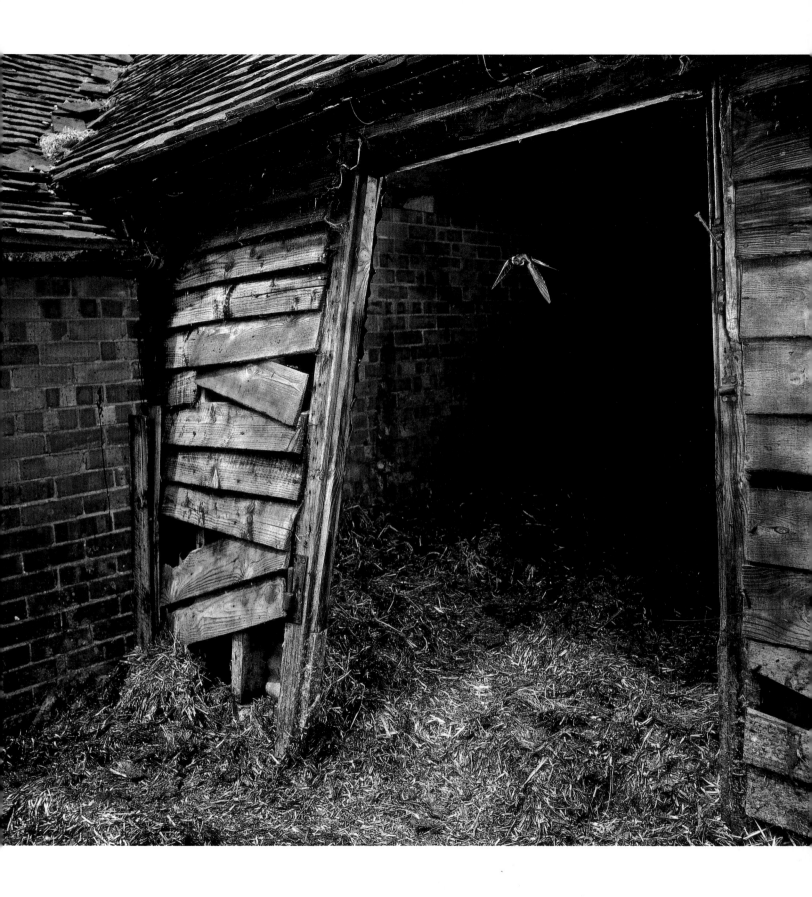

HOUSE MOUSE (*Mus musculus*)

A house mouse pauses briefly at the stable entrance before wandering in to scavenge for food scattered on the floor by the horse.

In the above photograph, a mouse rummages about for the food that has been specially put out for it among the broken flowerpots.

Like the brown rat, the house mouse has spread from Asia to every part of the inhabited world. Although this mammal can be found in the open countryside, it prefers to be close to humans, where food is readily available. Its success is due to its extraordinary adaptability and its capacity to breed prolifically. Each year, one female may produce several litters of between 6 and 12 blind, naked young, which develop so rapidly that they are independent within a couple of weeks. At 6 weeks of age, they are capable of breeding themselves.

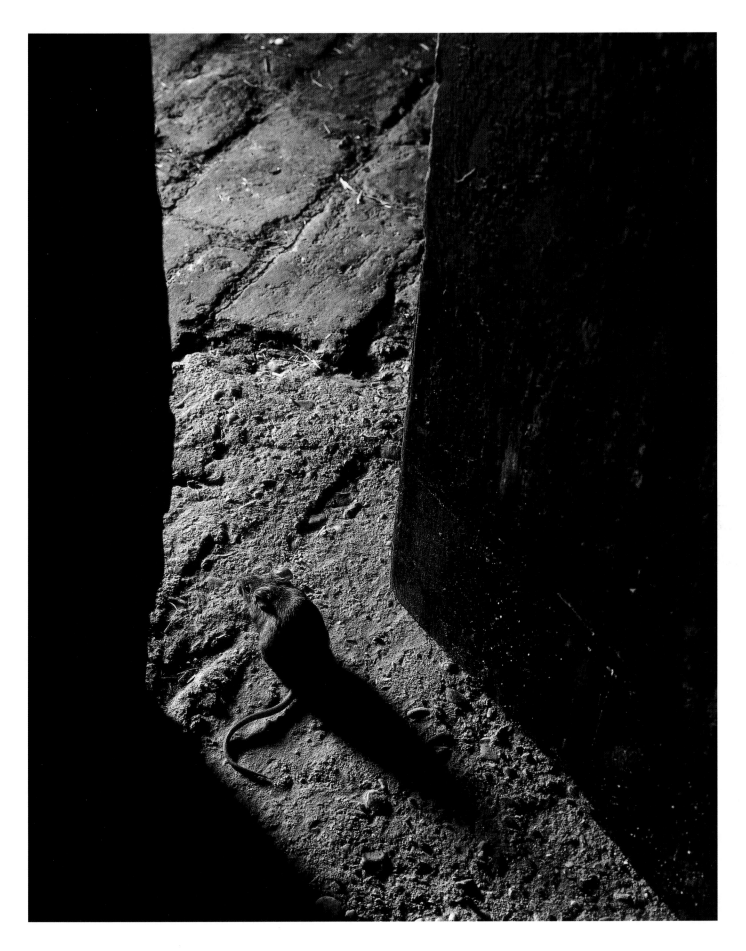

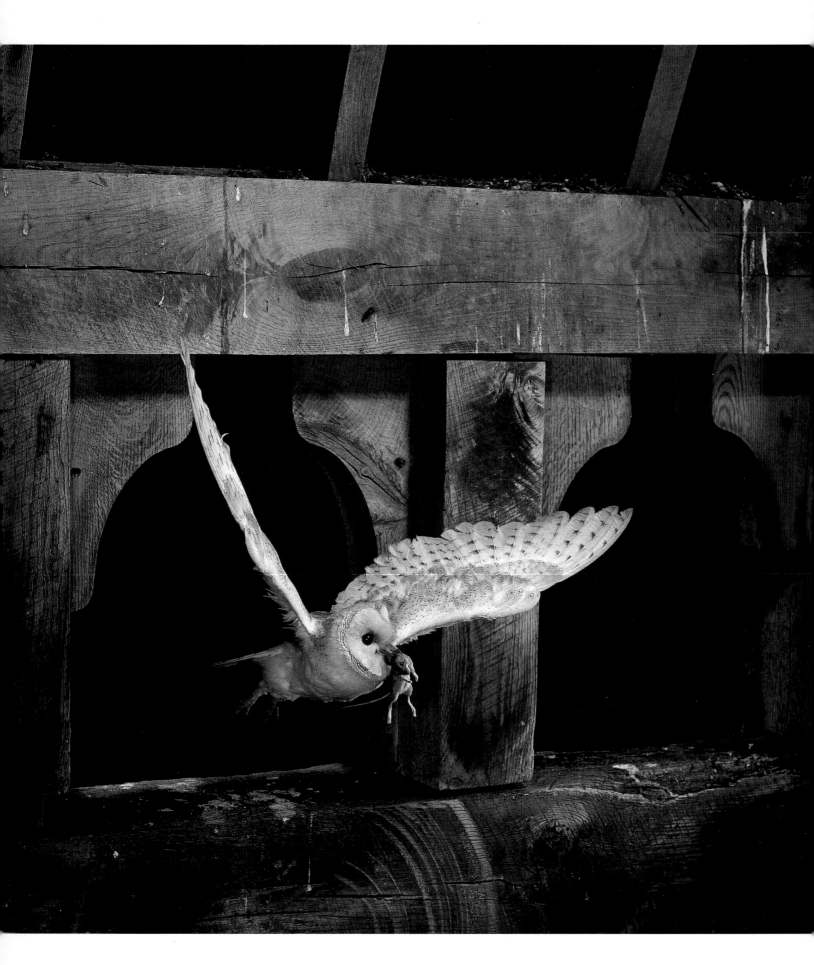

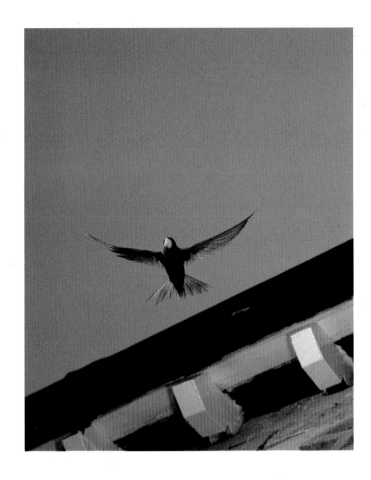

EURASIAN SWIFT (*Apus apus*)

Superficially similar to the swallow, this remarkable bird is more closely related to the nightjar than to the swallow family, but the swift can be easily distinguished by its relatively large, narrow, sickle-shaped wings. The swift spends virtually its entire life in the air—feeding, sleeping, mating and even collecting nest material on the wing—coming in to land only to lay and incubate its eggs and feed its young. Apart from the pale patch under its chin, the Eurasian swift is practically black in coloration.

The sight and sound of swifts streaking overhead in screaming parties is one of the pleasures of a warm summer evening. Having just fed its young, this bird is heading out from its roof-space nest to join its companions.

BARN OWL (*Tyto alba*)

Hollow trees and old buildings are among the barn owl's favorite nesting sites. Unfortunately, both are becoming increasingly difficult to find in England. Together with pollution, collisions with vehicles and the relentless destruction of real countryside, the decline of nesting sites has caused a significant reduction in the population of this magnificent bird over the past 30 years or so.

This was the second time I had the opportunity to photograph barn owls nesting in an old building. Once again, the operation took several weeks to complete, since much preparation was necessary, including temporarily blocking off numerous alternative entrances.

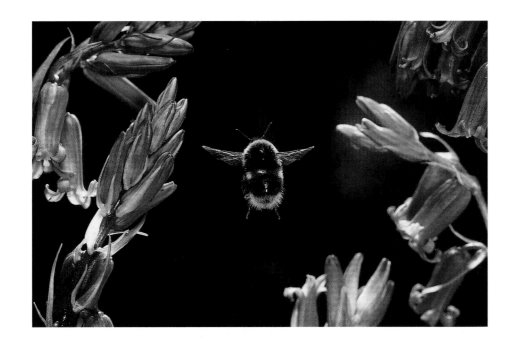

BUMBLEBEE (*Bombus* sp)

There are often more bumblebees searching for nectar and pollen among the garden flowers than there are honeybees, particularly in cold or wet weather, when honeybees tend to return to the warmth of the hive.

Bumblebees have well-organized colonies and divide the labor, but their nests, which are usually underground, consist of far fewer individuals than those of honeybees. Unlike honeybees, only the queen survives the winter to start a new colony in the spring. This bumblebee has been foraging among the spring bluebells.

DOCK FIELD AND RAINBOW

The part of our farm that we acquired in the late 1980s consisted primarily of pastures, of which the largest and most uninspiring—and the one afflicted with a plague of dock—is photographed here exactly 10 years after the change-of-management style implemented in 1988. With the addition of a fresh plantation surrounded by the Sussex fence, at left, the whole feeling of the local landscape changed for the better once the trees became established. A new badger set and a variety of bird species not seen in the vicinity before were at last attracted to a patch of land that had once been fit only for grazing.

'ROUND POND'

Another worthwhile improvement was effected when we fenced off a field and constructed a modest pond in one corner, photographed here during the fall. The pond was originally intended to have a natural shape, but unfortunately, as a result of marginal growth and the fullness of time, it turned out completely round!

After seven years of careful management, the little meadow prospered beyond my wildest dreams. Over 85 species of plants flourish here, while skippers, small coppers and common blue butterflies flit around the wildflowers and breed each year. Kestrels can often be seen hunting overhead, and sparrowhawks, three species of woodpeckers, two species of wagtails and tawny and little owls are also heard or seen regularly. A kingfisher was once spotted visiting the pond. Insect life around the water is especially rich, with 14 or so dragonfly species to be marveled at most years. A variety of small rodents live and breed within the meadow boundaries, while the larger mammals that pass through include fallow and roe deer, foxes, badgers, stoats and weasels.

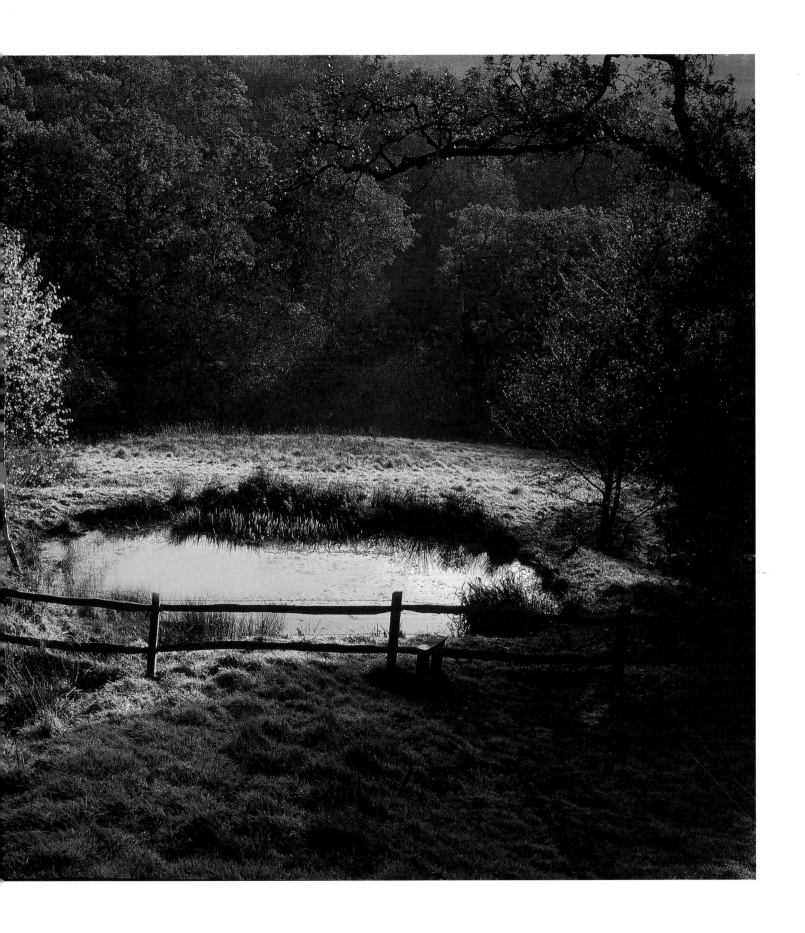

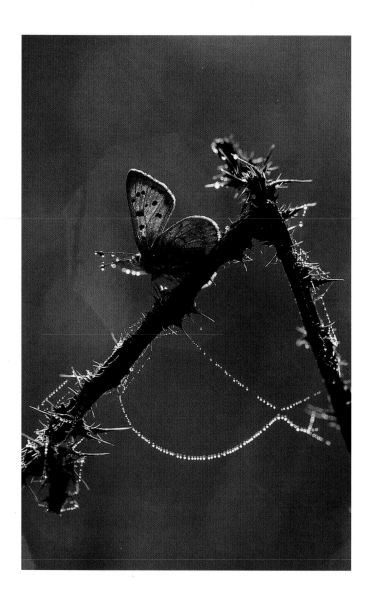

SMALL COPPER & COBWEBS

Early mornings in autumn are quite ravishing down in the meadow. Gently swirling mists and multitudes of cobwebs line almost every square inch of vegetation, and dew-coated insects, such as the small copper (*Lycaena phlaeas*) above, wake up to bask in the warming rays of the rising sun.

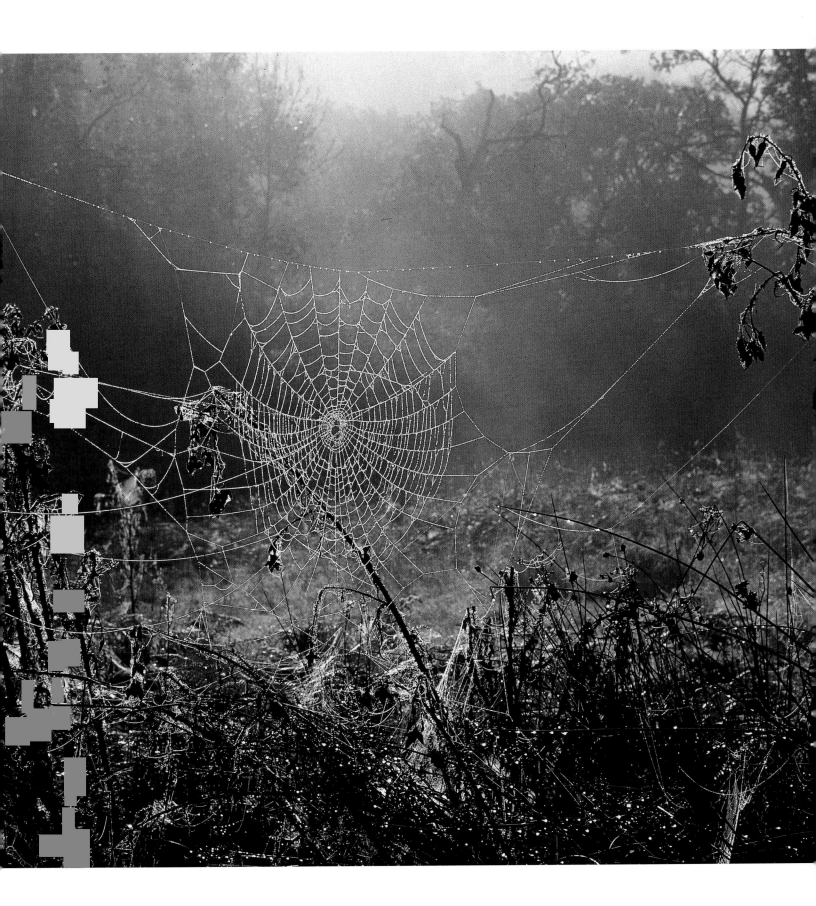

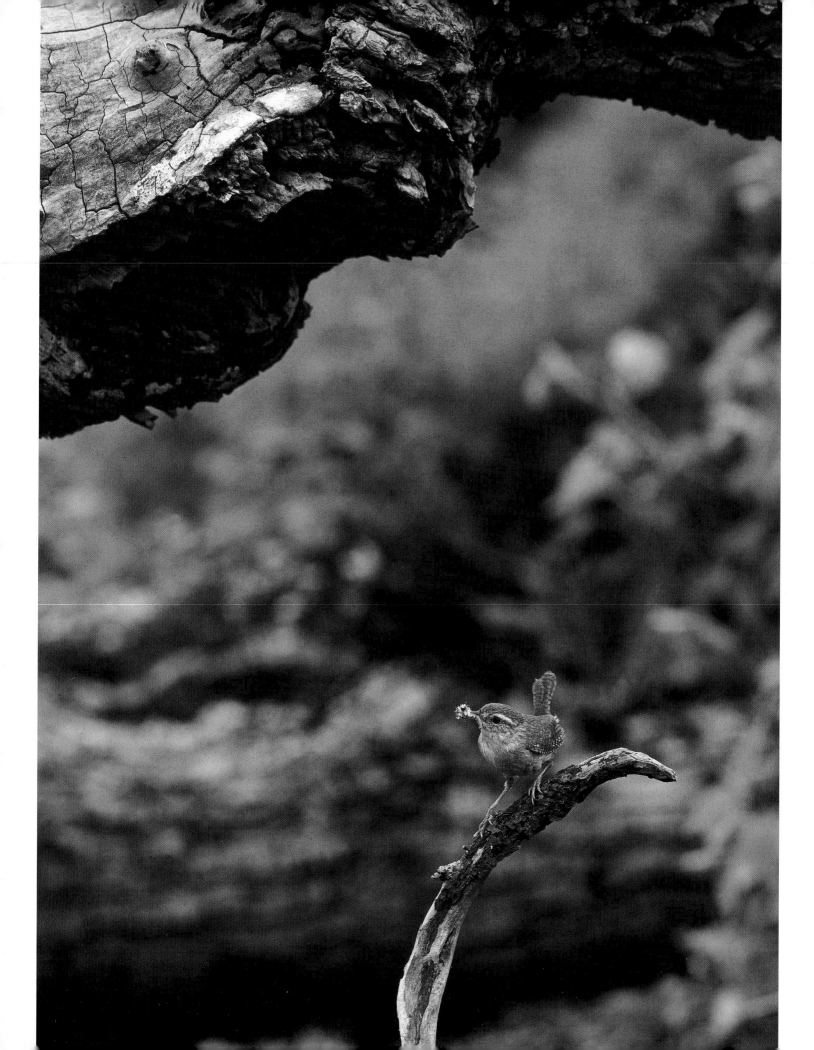

RABBIT (*Orictolagus cuniculus*)

Like humans, rabbits find it difficult to control their urge to mate. When present in large numbers, lagomorphs are an environmental menace. They can be found anyplace that will afford them a living—from fields and hedgerows to banks and woodland clearings. Sensing danger, this rabbit stretches above the long grass and bluebells to watch and listen for anything suspicious—in this instance, probably the photographer.

NORTHERN WREN (*Troglodytes troglodytes*)

Although basically a woodland bird, the northern wren can be found anywhere there is sufficient dense vegetation or low cover. Its brown plumage, uptilted tail and mouselike way of creeping about low in the undergrowth make it unmistakable. Its song and alarm calls are surprisingly loud and penetrating for such a tiny bird. Here, one has chosen to nest in a rotten walnut tree that had fallen among a thick patch of stinging nettles.

EUROPEAN SPARROWHAWK (*Accipiter nisus*)

My first encounter with this spectacular raptor was in 1970, while on a birding trip with my father in Wales.

The sparrowhawk usually makes its nest near the top of the highest tree it can find, but we located one only 20 feet up a hazel tree. So as not to disturb the bird unduly, we decided to spend a maximum of half an hour a day building the platform and blind in an adjacent tree about 15 feet from the nest. To our astonishment, while we were hammering nails into planks, the hen bird flew back to the nest to feed her fledglings, ignoring us completely—we need not have bothered with the blind at all.

In the normal course of events, the sparrowhawk is difficult to observe in the wild, as we tend to see it for fleeting moments. It is a master of the high-speed low-level surprise aerial attack, often flying just a few feet off the ground. All you see is a flash of gray and a cloud of feathers as some hapless garden bird is whisked away in the talons of this magnificent bird of prey, an event next to impossible to photograph successfully in the wild—if at all.

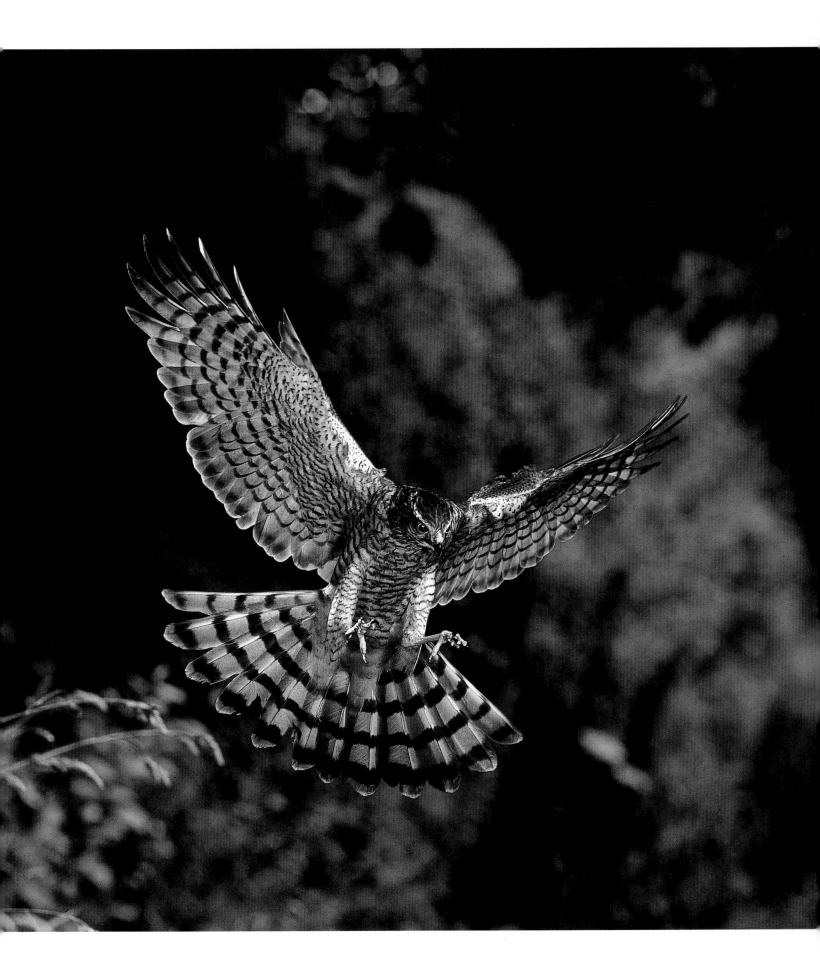

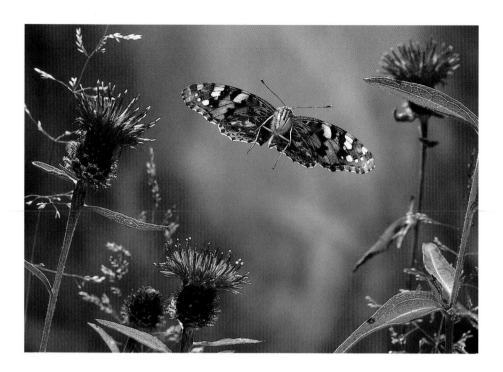

PAINTED LADY (*Vanessa cardui*)

Commonly found in the Mediterranean region, the painted lady migrates in midsummer to reach the northern European countries. It belongs to the Nymphalidae family, a group of medium-to-large-sized butterflies that are usually brightly colored and strong on the wing. Here, the butterfly flaunts its vibrant underwings as it flies among knapweed flowers.

YELLOW-NECKED MOUSE (*Apodemus flavicollis*)

Because of their athletic nature, the yellow-necked mouse and its close relative the wood mouse are often challenging subjects for the camera. Both species can be distinguished by their large ears and eyes and a tail as long as their bodies. They typically nest under a tree or in an underground woodland burrow, where they rear their offspring and store nuts and seeds for winter. Extremely supple and agile rodents, they move along in a series of zigzag bounds, with short pauses, and are capable of jumping and climbing with consummate skill. They need to be, for they have many enemies, among them owls, weasels, foxes and hedgehogs.

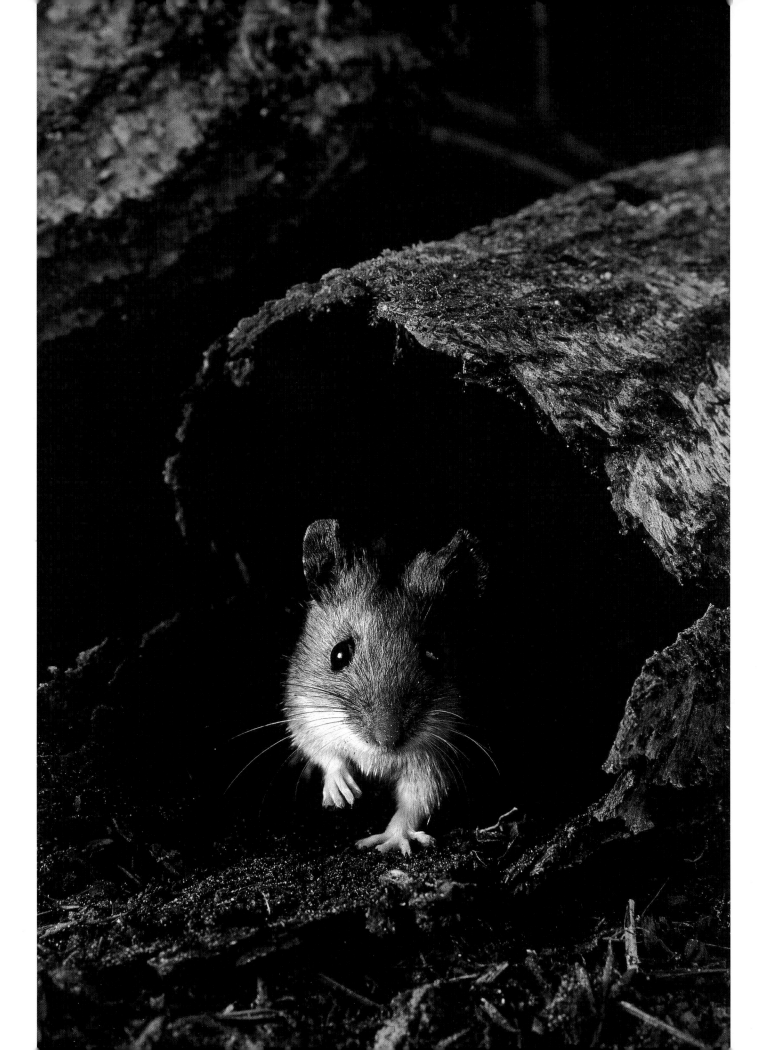

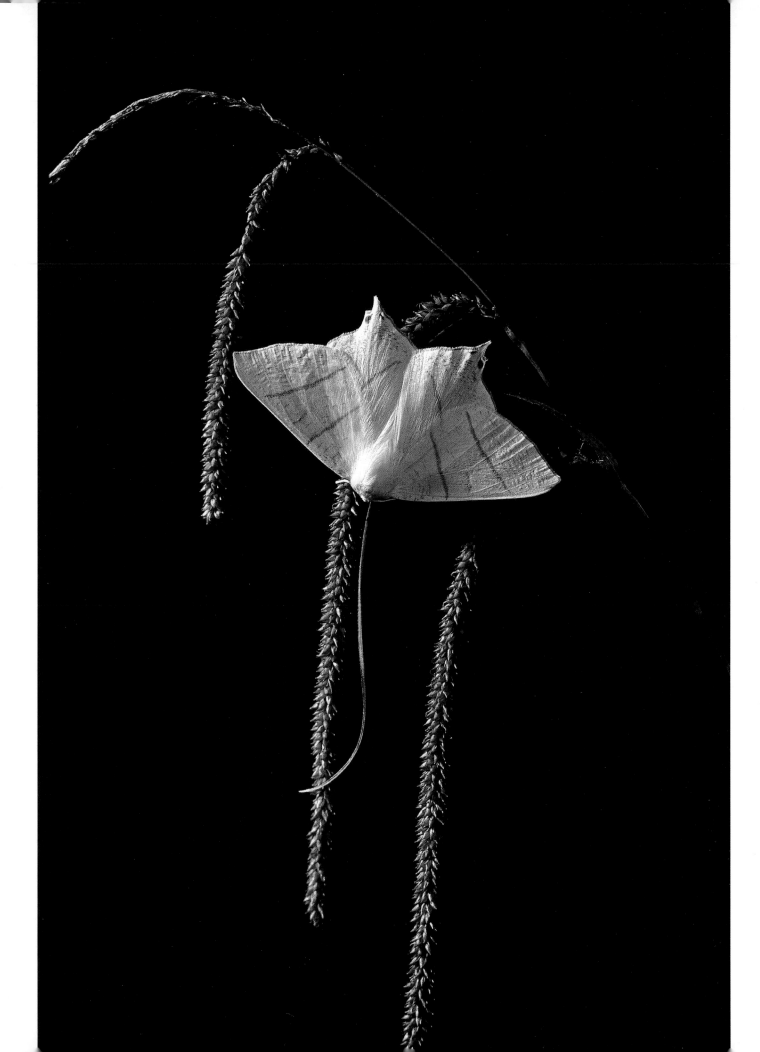

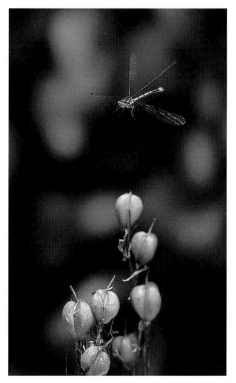

AZURE DAMSELFLY (*Coenagrion puella*)

In its search for food or a mate, the damselfly sweeps low over ponds and streams, frequently resting on floating vegetation or plants at the water's edge. Like the larger and more sturdily built dragonfly, the damselfly is carnivorous, although it seldom catches prey on the wing, preferring instead to pick up gnats, midges and other insects that settle nearby.

Generally smaller than a dragonfly, the damselfly has a feebler and more fluttering flight. Most species rest with their wings flat over their backs.

In the flight tunnel, dragonflies and damselflies are not the most enthusiastic of fliers, tending to doze off if certain conditions are not met. Both need bright sunshine and warmth to stimulate their flight muscles into action.

SWALLOW-TAILED MOTH (*Ourapteryx sambucaria*)

The delicate lemon-yellow swallow-tailed moth belongs to the Geometridae family, a huge group of flimsy-looking moths that are found on every continent. The adults tend to have a weak, erratic flight and are often attracted to lights.

The caterpillars are unusual in that they lack most of the larval prolegs in the middle of their body, so they move about with a looping gait—hence their various common names, such as loopers, inchworms and measuring worms. Many species resemble twigs and leaf stems, a protective adaptation that allows them to blend in with their surroundings.

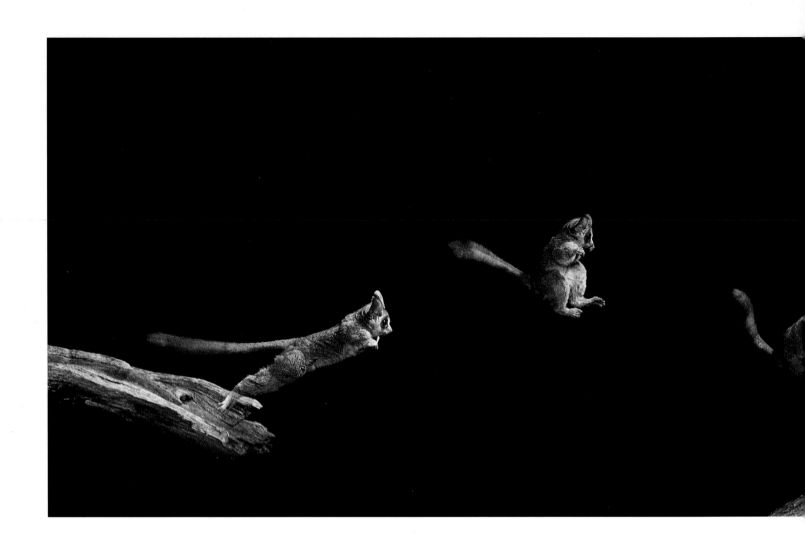

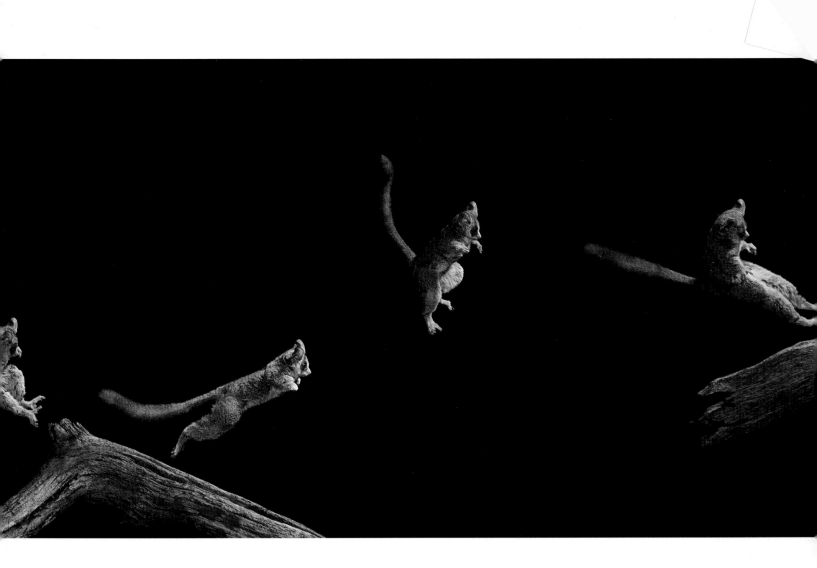

LESSER BUSH BABY (*Galago senegalensis*)

Surely the African bush baby must be the archetypal cuddly critter, not only in looks but in character. Indeed, this creature was so captivating that I sometimes found it difficult to turn away from. Its manner of locomotion on the ground was reminiscent of a soft, bouncy rubber ball, and the only way to demonstrate this in a still picture was to use multiflash photography in the studio. A number of modifications were necessary to get the 12 high-speed flash heads to fire not only sequentially in pairs but also reliably over the 10-foot-wide area needed to cover the series of leaps. To ensure that each image was in the ideal place, evenly lit and correctly exposed, the somewhat temperamental arrangement of electronic components had to be carefully checked between each run. Adding to the commotion, the high-strung animal was very inquisitive. It frequently disappeared among the studio paraphernalia and was sometimes reluctant to come out.

FIRE-BELLIED TOAD (*Bombina bombina*)

The fire-bellied toad belongs to a rather primitive family of toads that is found predominantly in Europe and Southeast Asia. The species pictured here is indigenous to Korea and China. Most frogs and toads catch their prey by protruding their tongues in a chameleon-like fashion; unable to do this, the fire-bellied toad must get very close to its prey in order to satisfy its appetite.

The green-and-black pattern on its back provides the fire-bellied toad with effective camouflage from above, and when the toad wishes to startle an enemy, it arches its back and displays orange-and-black warning colors on its belly and feet. If the threat persists, it secretes a toxic white foam from its skin. When water is nearby, the toad dives to the bottom of the pond at the slightest sign of danger. Its voice has been variously described as "subdued," "loud and melodious," "mournful" and a "musical bell-like ringing." I look forward to hearing the calls of the creature in its natural habitat to form my own opinion.

This particular toad—Norman was his name—belonged to an amphibian-breeding friend who was also a keen motor-cyclist. After the photography session, Norman was safely confined in a container, and my friend set off for home. Involved in a road accident en route, she suffered leg injuries, and her motorbike was a write-off. Poor Norman was found wandering about in the middle of a busy road by a passerby. Three years later, Norman was still very much alive and kicking, as was his owner.

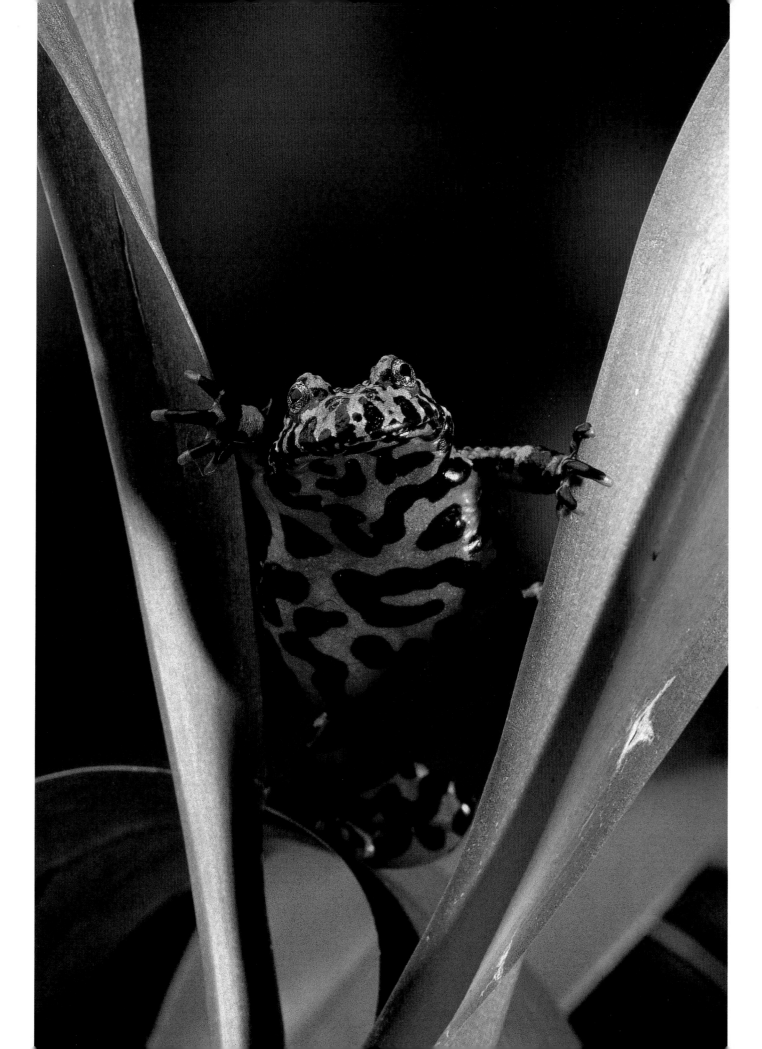

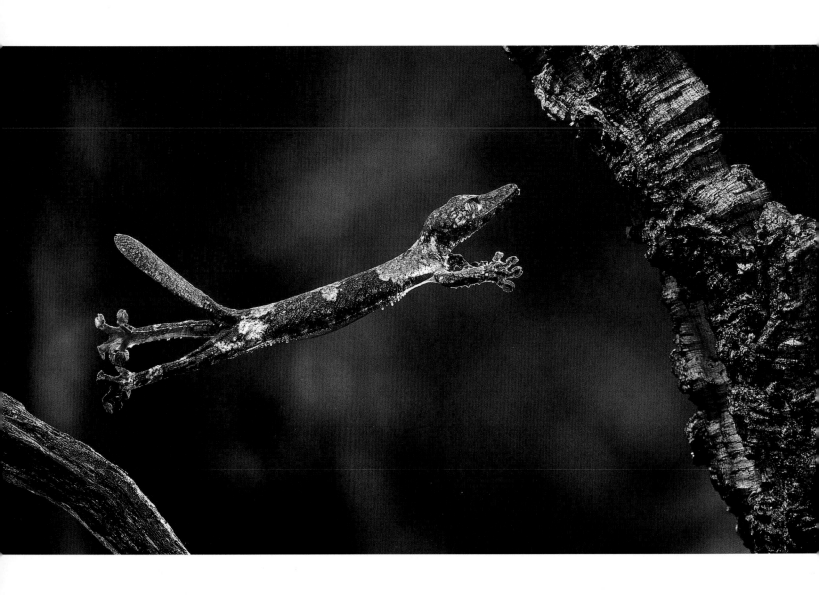

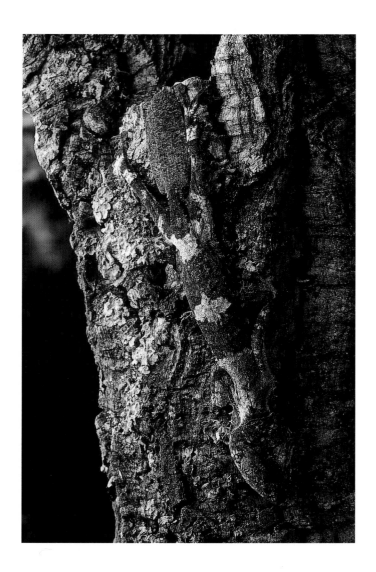

LEAF-TAILED GECKO (*Uroplatus henklei*)

Madagascar's leaf-tailed gecko is one of the largest of roughly 300 gecko species, the majority of which are nocturnal. This gecko has the ability to change color to blend in with the bark of the tree on which it lives. Here, the irregular pale patches on its body look amazingly like lichen. Thin hovercraftlike flaps are held in close contact to the sides of its body, limbs and tail, reducing the shadow cast by the animal and thereby contributing to its remarkable concealment.

My original plan was to take a straightforward photograph to show the camouflage of this splendid lizard, but along the way, I discovered that the slow, clumsy-looking creature is capable of impressive leaps. Thus "one morning" of portrait work turned into a long stint of high-speed photography that lasted for several days. The animal was fun to work with and needed no encouragement to take mealworms from my hand, sometimes ambling up to me from several feet away.

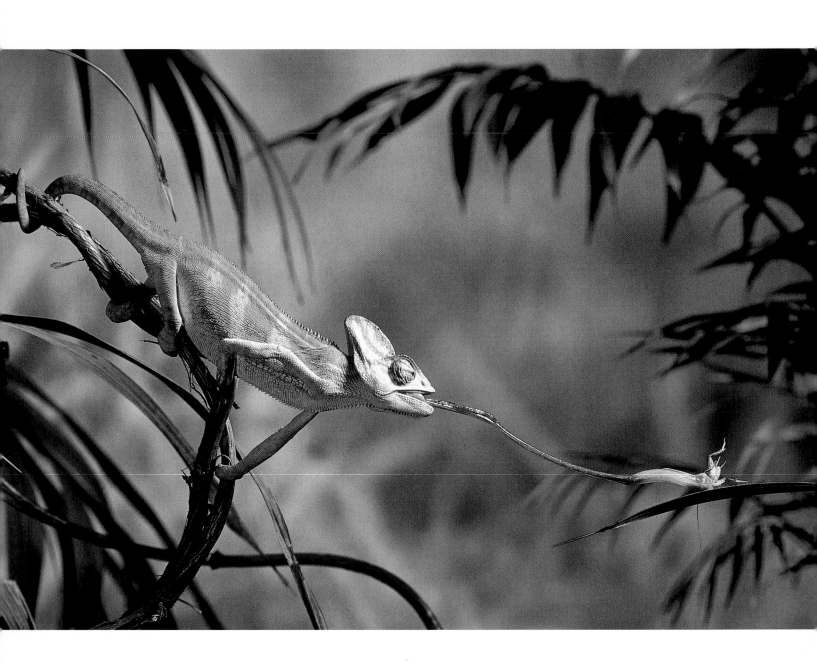

VEILED CHAMELEON (*Chamaeleo calyptratus*)

The chameleon is endowed with so many extraordinary attributes, it is difficult to find a more remarkable animal. Unlike most reptiles, which depend on speed to evade their enemies, the chameleon relies on subtlety. It moves in a slow, measured way, and each of its eyes can point independently in virtually any direction. It possesses strange feet and a highly prehensile tail and has the intriguing ability to change the color of its skin. As a *coup de grâce*, it catches its prey in a flash and unawares, as this veiled, or Yemeni, chameleon demonstrates.

Unfortunately, the chameleon is not the easiest reptile to keep in an artificial environment, so unless expert guidance is available, its captivity is not recommended. Before taking on any wild animal, it is vital to ensure that the creature has not been snatched from its natural habitat but is captive-bred, as this veiled chameleon was.

MOUNTAIN CHAMELEON (*Chamaeleo montium*)

The way in which a chameleon can merge into its surroundings is a characteristic that never ceases to amaze. I once turned my studio inside out looking for this mountain chameleon from the Cameroons, which had wandered off while my back was turned. It was eventually found hiding behind a vertical flash cable a couple of feet off the set. To appear inconspicuous, the little creature had compressed itself into an almost two-dimensional slither, so all I could see from the opposite side of the cable were six blobs resembling buds or broken shoots—four feet and two eyes. As I searched, the chameleon kept moving unobtrusively around the cable at the same speed, always keeping the cable between itself and me. It must have done several 360-degree turns before being discovered.

NORTHERN FLYING SQUIRREL
(*Glaucomys sabrinus*)

This squirrel inhabits the pine forests of Canada and the western United States. But rather than journey halfway across the world to set up a blind in the top of a tree with all the necessary photographic and electronic equipment, then wait for the nocturnal squirrel to fly past my camera lens, I chose to conduct the operation in the comfort of my studio at home in England.

Having constructed a large squirrelproof polyethylene enclosure within the studio, I arranged everything, complete with suitably indigenous branches, in the hope that the animal would unhesitatingly leap in exactly the right place in front of the camera. A couple of days' work, I reassured myself—but with wildlife photography, things rarely turn out as planned.

My problem was that this squirrel was lazy. It did everything in its power to avoid flying or jumping, preferring instead to climb up and down the stands, tripods, flash heads and plethora of wires running all over the set. Nevertheless, after painstakingly covering every cable and object in sight with slippery polyethylene and after 10 frustrating days, patience and determination eventually triumphed.

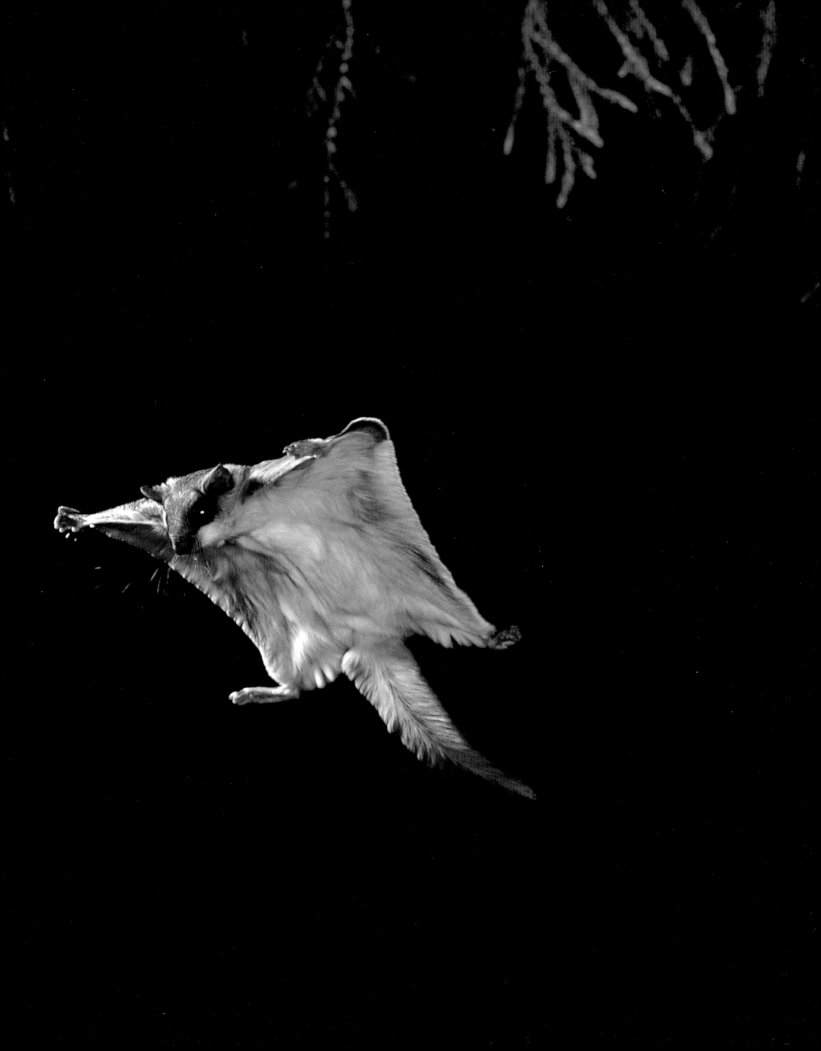

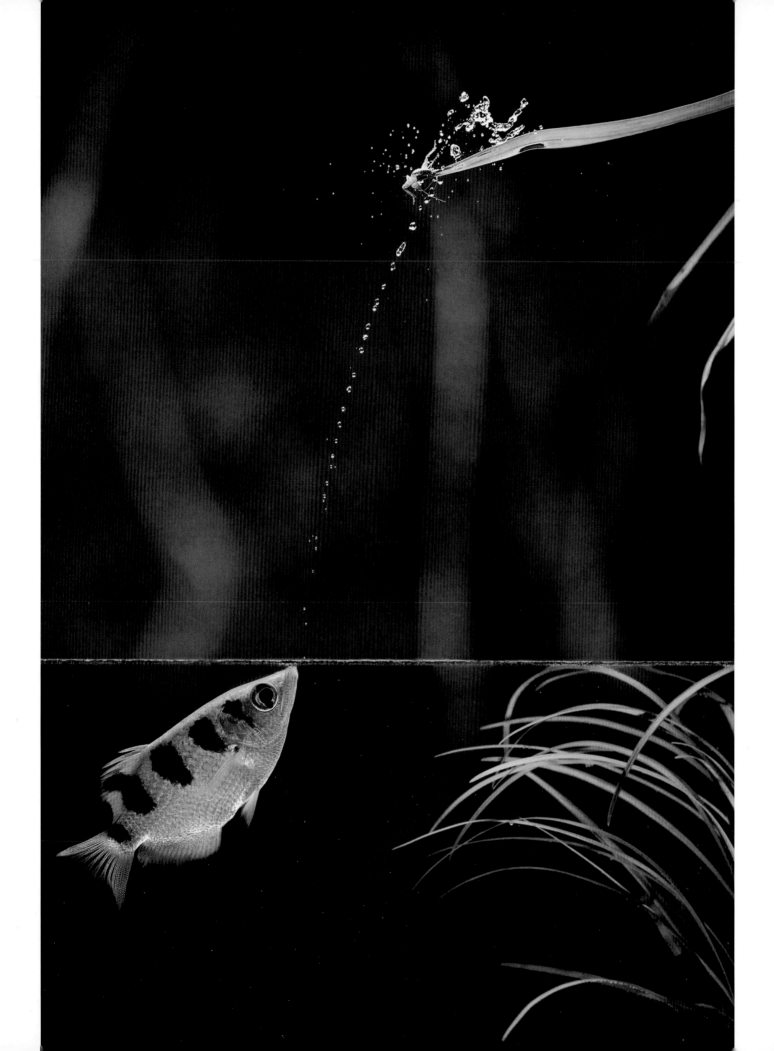

ARCHERFISH (*Toxotes* sp)

This extraordinary fish inhabits the brackish waterways of Indonesia. When it spots an insect in the air, the archerfish swims cautiously upward, sticks its snout just above the surface and squirts a narrow jet of water that knocks its victim into the water, where it is promptly seized.

I almost gave up trying to get this shot. My fish seemed to prefer to have insects lobbed into the water by hand rather than to perform for its living, but a week or two of training finally paid off. Photographically, the chief difficulties were in avoiding reflections on the glass from objects inside the aquarium—a task that proved a lot trickier than I had expected—and getting the triggering beam exactly in line between the lively crickets and the anticipated position of the fish's snout. The saline water had to be specially formulated, while the aquarium likewise was custom-made to the right dimensions, with split-level sides.

One day, on hearing ominous dripping sounds, I entered my sitting room, which was acting as a temporary studio at the time, only to find the carpet squelching with 15 gallons of salty water. The poor fish was weakly flapping about on the floor, having leaped out of its now far from ideal piscatorial habitat. Apparently, one of the pipes for pumping the filtered water had come adrift, allowing the water to be recycled to the floor rather than the tank. A massive rescue and mopping-up operation involving the whole family was put into force, and the fish, which had by then become a much-loved member of the household, survived. In fact, this photograph was taken just a day or two after the creature's exciting misadventure.

All references are to photographs.

All references are to photographs.